HOW TO DRAW
MANGA ANIMALS

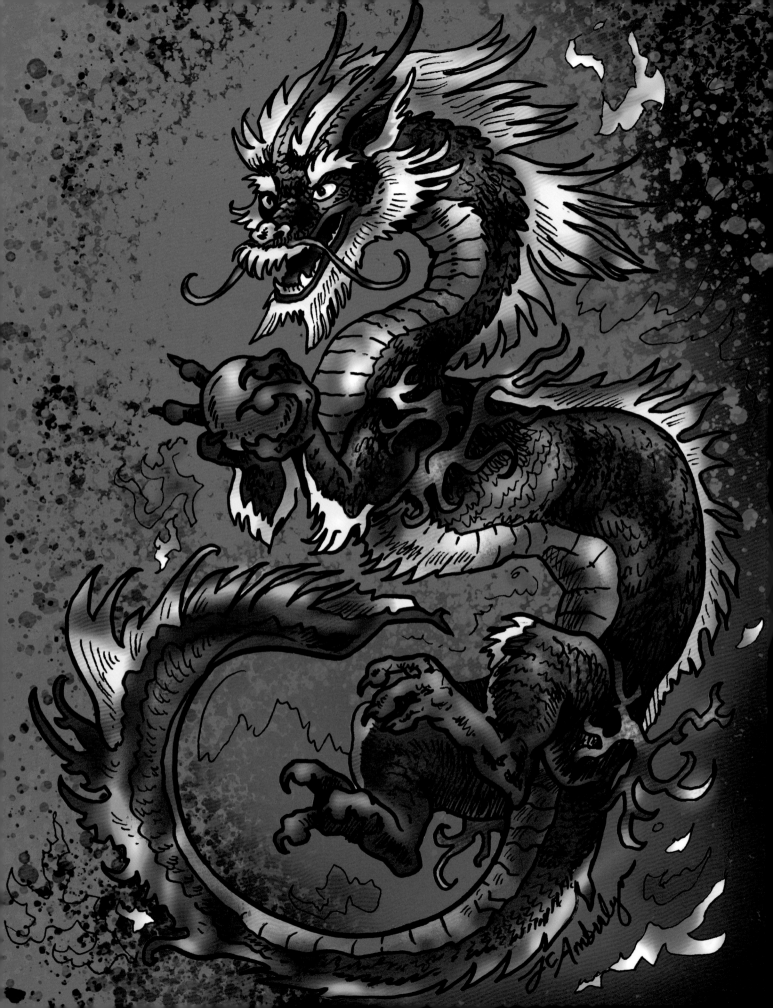

HOW TO DRAW
MANGA ANIMALS

A BEGINNER'S GUIDE TO CREATING CHARACTERS

J.C. AMBERLYN

MONACELLI STUDIO

Published in the United States by MONACELLI STUDIO,
an imprint of THE MONACELLI PRESS, a division of Phaidon

Library of Congress Cataloging-in-Publication Data

Names: Amberlyn, J. C., author.
Title: How to draw manga animals : a beginner's guide to creating characters / J. C. Amberlyn.
Description: First edition. | New York : Monacelli Studio, [2021] |
 Includes index. | Summary: "In this book, we look at creating a cast of
 manga-style animal characters. What makes a good character design? This
 book looks at elements in creating a manga-style animal character with
 appeal, exploring archetypes and other familiar types of characters as
 well as how to add unexpected or unique elements that give your
 characters a memorable twist. You'll learn to draw cute chibi critters
 and dangerous-looking monsters and everything in between for comics,
 games, or simply your own personal enjoyment. This book includes
 chapters on some common or notable real and mythological Japanese
 animals to provide readers a foundation of knowledge to start their own
 animal character designs"-- Provided by publisher.
Identifiers: LCCN 2020045144 | ISBN 9781580935623 (paperback)
Subjects: LCSH: Comic books, strips, etc.--Japan--Technique. |
 Cartooning--Technique. | Animals in art.
Classification: LCC NC1764.8.A54 A43 2021 | DDC 741.5/952--dc23
LC record available at https://lccn.loc.gov/2020045144

ISBN: 978-1-58093-562-3

Printed in China

Design by Jennifer K. Beal Davis
Cover design by Jennifer K. Beal Davis
Cover illustrations by J. C. Amberlyn

10 9 8 7 6 5 4 3 2 1

FIRST EDITION

MONACELLI STUDIO
THE MONACELLI PRESS
65 Bleecker Street
New York, NY 10012

www.monacellipress.com

THIS IS DEDICATED TO MY
FAMILY, FRIENDS, AND ALL
THOSE WHO HAVE SUPPORTED
MY BOOKS AND ART THROUGH
THE YEARS. THANK YOU.

CONTENTS

CHAPTER 4
DRAWING REAL ANIMALS MANGA-STYLE 90

CHAPTER 5
DRAWING MYTHOLOGICAL CREATURES 140

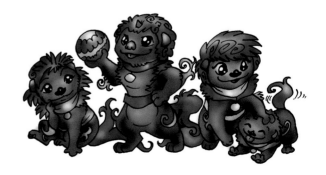

INTRODUCTION

Memorable characters bring stories and art to life. Whether heroes or villains, clowns or wise guys, mascots or sidekicks, they are often long remembered. Artists use various techniques to visually inform the viewer of a character's nature and role in the story. A good character design gives a viewer an immediate connection to the character. In this book, we'll explore the elements of good character design for creating interesting manga-style animal characters for comics, video games, or simply for fun.

We will explore this approach to character design with a focus on animals. We share our lives with domesticated and other animals and benefit from contact with wildlife and nature. Our interactions with animals help form our own culture and expectations in society. Whether your story or art features a predominantly animal cast or you simply want to add some animals for flavor and realism, knowing how to design animal characters will be beneficial to you.

When you're designing a character, you're connecting to both internal and external factors, to universal archetypes, as well as your own personal experiences. It's the blend of universal and personal that can make each creation unique and compelling. Conveying universal truths and parts of the human experience in a clear and easily understandable manner provides you or your audience an immediate connection to a character or story. Adding your own personal touches is what makes that character unique and interesting.

This book examines the elements in creating a manga-style animal character with appeal, exploring archetypes and other familiar types of characters, as well as how to add unexpected or unique elements that give your characters a memorable twist. Through detailed step-by-step demonstrations, you'll learn to draw cute chibi critters and dangerous-looking monsters and everything in between for comics, games, or art. This book includes chapters on some common or notable real and mythological Japanese animals to provide readers a foundation of knowledge to start their own animal character designs.

Ultimately, good character design, and good art, comes from experience. Good character design and art resonate with people because they invoke emotion, some sort of connection. They come from practice, from learning, from observing and recording the world around you, and then taking all that you've seen and translating it into something of your own. It's okay if it's not perfect. So few things in life actually are. Every new bit of knowledge, every bit of experience, and every attempt at trying a new thing all contribute to a deeper understanding, even if it's not obvious to you at first. Even the failures, or perhaps especially the failures, will teach you and help you grow. Never be afraid to try. The important thing is to keep learning, keep trying, keep sketching and drawing. Observe the world around you and you'll find it start to connect in ways you might not have expected—and oh, how exciting that can be!

MATERIALS

The main thing you'll need for this book is some sort of drawing medium, whether it is pencil and paper or a computer art program with a pen tablet, any medium you create characters with.

A lot of the artwork for this book was created with a **mechanical pencil**, then **ink pen on paper**, and then **scanned** into the computer.

I like **kneaded erasers** for control over the size and shape of what I'm erasing. Other elements were drawn or colored with a **Wacom art tablet**, which allows me to "draw" with a computer pen straight onto the screen. A good **scanner** is helpful if using traditional mediums so that art can be scanned into the computer. Scan at least 300 dpi (dots per inch) for good quality scans. Finally, bring your **heart and mind.** They house your experiences and creativity and are the primary things you'll need when creating compelling new characters. Connect to your audience's hearts and minds, even if your audience is simply yourself, and you'll find success.

Manga, or Japanese comics, and Anime, or Japanese cartoons, have taken the world by storm and captured the hearts of many with their elegant, stylized, and often whimsical creations. From *Pokémon* to *Animal Crossing*, from numerous anime and manga series to the work of online artists, this art form from Japan inspires and entertains millions every day.

STORIES & CHARACTERS

Concepts for Creating Manga-Style Characters or Creatures

What comes first in character design, the character or the story? This is really a "chicken or the egg" question, without a clear answer, because it can be either. Sometimes inspiration strikes with a character concept and you build your story on that idea, and sometimes it's the story that comes to you first and you hen populate that story with appropriate characters. Let's ake a look at the two ways to begin your creative process.

WHO'S YOUR CHARACTER? WHAT'S ITS STORY?

Sometimes your initial inspiration to create comes from a character idea. What if there was a character who thinks and acts like this and struggles with that? Whatever "this" and "that" are, the character should spark enough conflict and interest to make you and your potential audience want them to develop further and see how they react and grow. Or perhaps you have a passion for some creature that lives in your imagination and you want to develop them more, see who and what they are, and what challenges they might face. And, sometimes, you just like drawing something! Once you have an idea of who this interesting character is, you can develop a story for them.

Conversely, sometimes the story comes first. Perhaps you visualize a world that has something different and interesting to you, some challenge or property to it that you'd like to explore further. Maybe there's a problem you see in real life and you'd like to throw some characters into that mix and see how they might react, or even solve, that problem. Once you create your scenarios, you need to invent characters to live in that world and make it come alive.

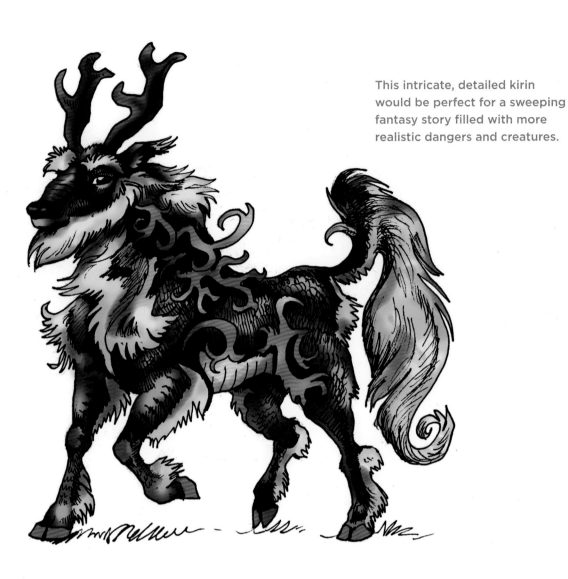

This intricate, detailed kirin would be perfect for a sweeping fantasy story filled with more realistic dangers and creatures.

This more cartoonish kirin would fit a cheerful, bright video game or comic full of cute critters, and an inviting colorful world.

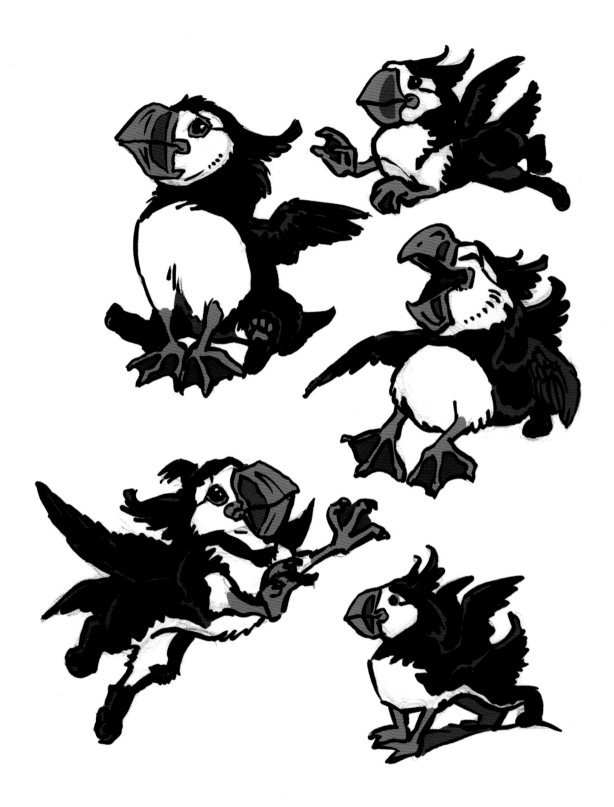

Puphons are creatures I simply enjoy drawing. I got the idea of taking the traditional gryphon (half eagle and half lion) but replacing the eagle with a puffin, the funny little seabird with the colorful bill. This led to a humorous creature that is a lot of fun to draw. Something like this could lead to ideas for a story: What are these creatures? How are they like traditional gryphons and how are they unlike them? Do they live near the ocean? How do they survive? Do others see them as silly and fun, as I do? How do they react to that?

Regardless of how the inspiration hits, there's no wrong way to express it. Creativity and inspiration can come from almost anywhere and simply need someone willing to take those ideas and develop them. That is what this book will aim to help you do. Regardless of whether the character or story comes first in your mind, both are important for developing a concept that brings a new world to life.

Stories affect the characters in them, and characters affect the stories they are in. You may have a specific story in mind, but as you write it, the characters may take in-character actions that lead the story in different directions than originally planned. It's exciting when that happens. The story will affect the character, as well, and the tone of the story sets the tone for the characters that populate it. A beautiful world full of cute, cheerful, and friendly beings probably won't have true horrific undertones. Think of something like *Pokémon*, which has somewhat dark elements,

but nothing excessively horrifying. Likewise, a more horror-genre story probably won't have lots of cute, fluffy critters in it. The horror video game *Five Nights at Freddy's* has what on surface appear to be cute, friendly animal mascots, but even they hint at something far darker lurking underneath with their unsettling, mask-like faces and frozen, fake, toothy smiles.

Japanese anime, manga, and video games have a rich variety of animal characters that range from the cute monsters of *Pokémon* to the simple, appealing designs of *Hello Kitty* to the very stylized, detailed, powerful, and impressive-looking creatures found in the *Final Fantasy* games by Square Enix. Each inspired creature is expressed in a language of shapes, colors, real-world life, and otherworldly mythology. Many elements of manga-inspired animal character design are universal but some draw on a knowledge of Japanese culture, aesthetic, and native life, which will be looked at in later chapters.

How does the character help you tell the story?

Whether the story or character came to you first, to develop any kind of believable world, you must come up with the fundamental, **basic concept** of what your story is about. Generally, it will be something interesting to you combined with an idea of a challenge or problem one might encounter in pursuit of this basic concept—a challenge or problem that your characters can overcome. And it doesn't have to be a bad or dangerous thing.

Look at James Gurney's *Dinotopia* book series. He simply asked what would happen if

people and dinosaurs lived side by side, and made an incredible series of illustrated books answering that fundamental question.

Master animator and filmmaker Hayao Miyazaki posed a lot of different questions in his many wonderful movies, such as what would happen if children could meet forest spirits face-to-face, as in *My Neighbor Totoro*, or whether living people could slip into the spirit world itself, as in *Spirited Away*.

Rusty the Red Fox was my first (published) story (in a local newspaper), created when I was 10. Rusty was born from my love of wildlife, the woods and hills around my home, and an intense interest in foxes. I tried to see the woodland world through the fox and his animal friends' eyes. I called my comic strip *Rusty the Red Fox and His Friends*. The strip explored what happened when these woodland animals encountered a forest fire—how did they react? how did they escape?—questions that helped develop the story. As I documented the animals' adventures, people told me that my story had opened their eyes. Some had never considered how wildlife dealt with a natural disaster. I was glad to have introduced them to that idea, and, I hoped, help them have more compassion for the struggles of wildlife in the real world.

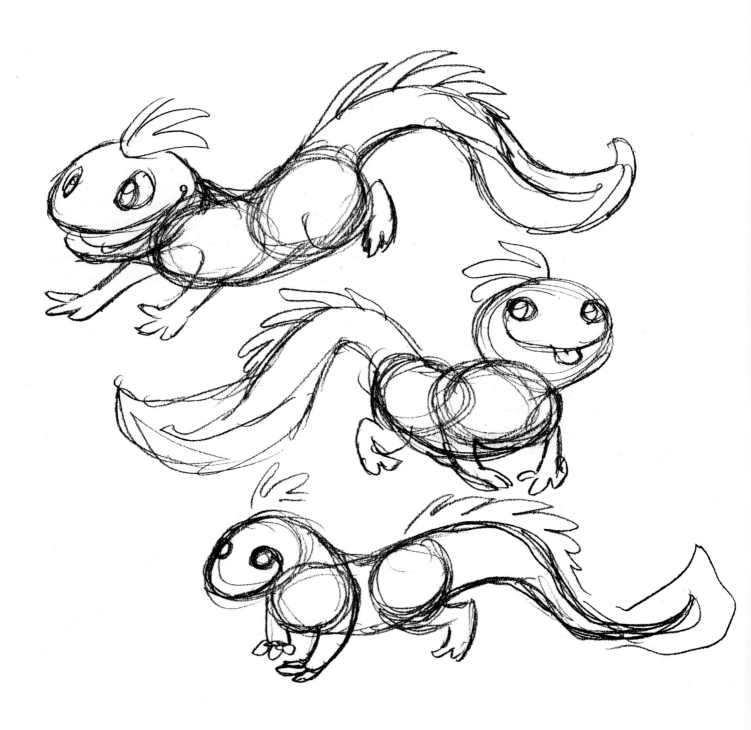

This cute salamander-like creature could easily populate a video game. It has a simple design that would be easy to model or create in animation and an appealing look appropriate for a cute monster one would catch *Pokémon*-style, or perhaps have as a traveling companion or pet.

Many stories feature a **Hero's Journey** (described in more detail in chapter two, on page 31). The protagonist must face and conquer some sort of challenge, usually through education and by improving skills, until that problem can be met head on and defeated with the newfound power and knowledge. Think about yourself and your own experiences and what sorts of challenges you've faced and overcome, or are trying to overcome. How could those experiences be used in a story? It doesn't have to be a literal interpretation; you can draw from real-life events, experiences, and emotions. The reason "write what you know" is an adage is because it works. When you experience something yourself, you can dive deeper into the emotions, difficulties, and triumphs of that journey better than if you haven't experienced it. Perhaps you've dealt with bullies. Your story might take those "monsters" from your life and make them literal monsters in your plot—ones your hero can fight and defeat. Have you felt lonely? Perhaps write a story with character who's all alone in a strange world and see how that character overcomes that. Of course, you don't have to always write what you know, but it can be a good starting point. From there, your imagination is the limit, so don't be afraid to explore unfamiliar subjects, too.

Video games have their own stories to tell, and the creatures that populate those worlds add a lot to the plot. Artists and authors sometimes simply want adversarial animals as naturalistic obstacles. You may not have a character in mind when designing creatures for these worlds so much as knowing you want cool monsters for your hero to fight. When you have some idea of each creature's story, their place in the world, and what motivates them, it will help you create convincing and engaging interactions. Why does it do what it does? How does it go about doing that? Is it motivated by food, by protecting its offspring, or is it an evil creature that simply loves mayhem? Is the world it lives in a fantasy world filled with beauty and danger; a cheerful, colorful, and cute place filled with adorable creatures; or a realistic one not unlike our own? All these factors will influence the design of the creatures you make.

When designing an animal or creature for any role, begin with its basic concept, then flesh out that concept with the **character traits** and **motivations** you want to explore. The stronger your concept, the stronger your designs will be. Take the time to figure out what it is that you find unique or interesting about this character, visually or in concept, and go from there. Explore something that looks really cool to you or a trait or concept you'd like to develop further. You can do this in your head, with words on paper, or with doodles and sketches. There's no wrong way. Just do something to get the creation process started.

What's the end product?

Designs will differ according to their purpose. Designs for characters in a manga series will be different from designs used for a video game. The simplicity or complexity of the design will be determined partly by the intended end product.

A creature designed for animation will likely be simpler than one designed for a lavishly illustrated book. In hand-drawn animation, the same character has to be drawn hundreds or thousands of times, and a simpler design is easier to repeat with consistency.

A simpler character is also easier to make recognizable from all angles ad perspectives. Even in 3D animation, a simple design is easier to make instantly understandable to the viewer or game player. While a 3D animated character can be more complex than a hand-drawn one, a simpler design is still easier for you to animate and to clearly convey its behavior and actions to the audience. Anything overly complex is likely to confuse and frustrate people.

On the other hand, if you are designing a creature for yourself for the occasional illustration and love delving into detail, then have at it! Add all the detail and complexity you want. You know best how much detail you can draw consistently to make it always look like the same character.

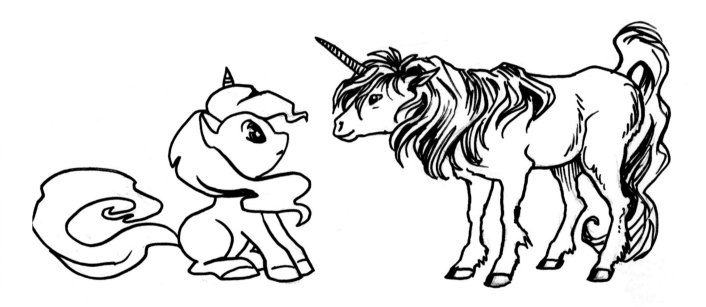

Your end goal will determine how you design your characters. The simple, cartoony unicorn on the left is more suited for some things (like repetitive drawing and animating) than the more detailed unicorn on the right, which fits others.

MAIN, SUPPORTING, AND BACKGROUND CHARACTERS

Another factor in the simplicity vs. complexity of your character's design is whether it is a main, supporting, or background character.

Main characters tend to have more detail and striking design characteristics than supporting and background characters. It makes sense to put more thought and "wow" factor into the characters the audience will most often see and spend time with. That doesn't mean you don't put thought and care into the other characters. You do. A well-designed cast will provide visual interest at every level and in every layer, and all characters should support the general feel of the world they inhabit, whether they are the main attraction or anonymous inhabitants.

In manga, the main character will often have some kind of a striking hairstyle, bright colors, or some other clue that this individual stands out from the crowd. Main characters often display primary colors like yellow, red, or blue to pop out from the rest (see more about color theory on page 47).

This brave young cactus mouse may be slightly injured, but that doesn't dampen her spirit. She stands out as a main character in several ways, from the cast on her arm to her yucca-plant-blade walking stick. The supporting cast of characters adds visual interest to her character. Her best friend, a kangaroo rat, is similar enough to fit with her, yet just different enough to have a distinct identity.

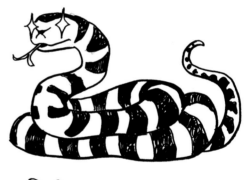

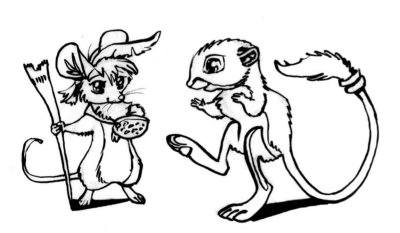

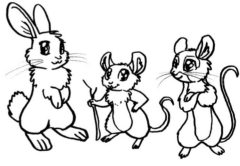

Meanwhile, cactus mouse's striking and dramatic nemesis is the kingsnake who wants to eat her! The background cast of other mice and small animals may not stand out as much as cactus mouse, but they add interest, layers, depth, and life to the created world.

Supporting characters

Supporting characters may not be main characters but they should be memorable and interact in meaningful ways with the main character. They support, enhance, and complement the main character—by bringing a nice contrasting color scheme or simply by looking cool standing next to the main character. They should stand out as interesting characters on their own but not overpower the main character, the star. (As an exception, an antagonist/bad guy that your main character has to grapple with all the time can be a co-star.)

Supporting characters should also support and enhance the world you're trying to establish. They should fit in with the population of that world and the setting you've chosen.

Background characters

Background characters do not stand out like main or supporting characters do; they are there to populate and bring the world to life and provide a backdrop for the main cast. However, they can still be interesting. Visually interesting background characters and creatures can add extra depth and interest to your video game, manga series, or whatever it is you're designing.

Character designers often strive to make sure background characters are unified with a theme. Is your story set in a cold place? Then perhaps your background characters live in a Nordic-themed village and wear cold-weather clothing. If your main and supporting characters wear brighter, primary colors, your villagers could wear more muted browns and gray-blues. Perhaps your video game is populated by jungle-dwellers in reptilian and tropical themes—scaley or feathered creatures in the greens of various frogs and some of the bright colors of tropical birds can decorate your background characters.

Perhaps you're designing an underwater world and would like the background characters or creatures to resemble fish. There are so many different and amazing fish and underwater invertebrate species that can provide an endless source of inspiration. From left to right: a dwarf gourami, a dwarf shrimp, and an angelfish, all interesting and colorful underwater species.

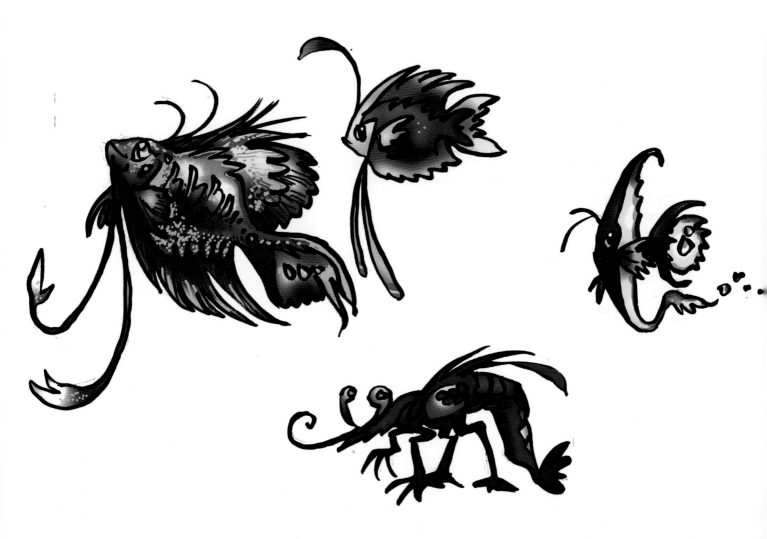

I took elements I liked of each of the species above and exaggerated or played with them to create new versions. Your imagination is your only limit, and you can go much further than I did. The angelfish creature, for instance, looks like it has fire coming from its tail. How would an underwater creature produce fire? Or, could it be some sort of spiritual energy, something like a will-o'-the-wisp, producing eerie light in bogs and swamps? This thinking could lead to many different ideas, such as a ghostly fish-like creature with a will-o'-the-wisp style of energy ball on its tail, ready to mislead nighttime adventurers. Why would it do that? Is it mischievous? Or, does it guard some treasure it doesn't want people to find? One idea can lead to another and eventually you've got a whole story imagined and ready to go! Even if your viewers or players don't know the background story, it can still add to the richness of your imagined world as you create it.

DESIGNING AS A GROUP EFFORT

Designing with a group of other people is a very different process from designing characters on your own. In a group effort there is a lot of give and take, brainstorming, and many rejections before arriving at the final design. These rejections are not to be taken personally. The creative process involves constant experimenting and all sorts of "what ifs," some of which will be more successful than others. The ability to edit out the things that don't work and keep what does is essential if you want to get to the core of what really will make your initial idea work in the end. Constructive criticism aids the process. It can be hard sometimes, especially if you like something that the other Creatives have given the axe to, but it's important when working on a group project to work as a team, and taking criticism and having ideas rejected is part of that. Be prepared to incorporate input from your team, and be willing to try new things. Sometimes you'll be surprised just how well it ultimately works. Overall, having a good attitude while going through the inevitable revisions will make people want to work with you on other projects in the future.

Working on a group project can be challenging at times, but also rewarding.

GETTING IDEAS

Ideas are everywhere. Your own imagination is where you begin and end this process, but you can use outside sources to inspire you and give you new ideas. **Movies**, **books**, and **games** can all supply inspiration: perhaps there is a creature or the way a character is designed that you really like. This can provide the spark for ideas of your own. You don't want to copy and plagiarize other people's ideas, but using some small part or spark of an existing character, as long as it isn't recognizable as belonging to that character, can be a good base for new designs.

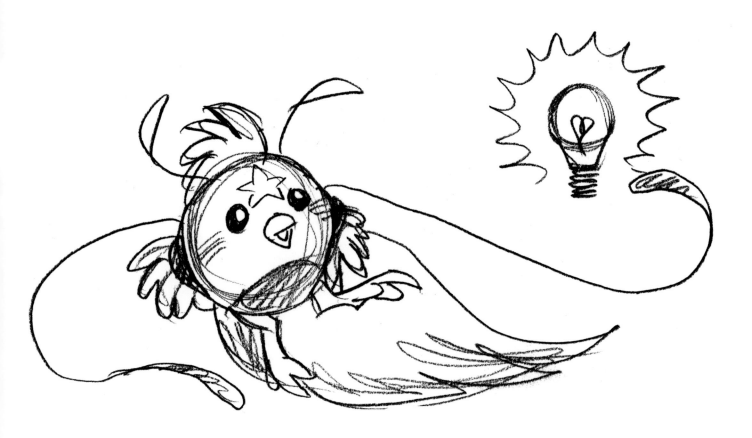

Keep alert for ideas. You never know when they'll show up!

Another source of ideas and inspiration is the **Internet**. Looking through online image and art galleries can inspire all kinds of new and fresh character designs and lead you to more visual sources. Look at what other people are drawing, sure, but also look for other visuals that interest you. If flowers fascinate, collect images of them. If the ocean calls, create a library of sea images that speak to you—underwater images for the interesting way that light and color filter through the water; rocky shorelines, because the dark, jagged shapes against the wet, wild waves look cool.

Nature and **the outdoors** provide more inspiration. Take photographs of anything that grabs you, even things that aren't obviously character-related, like an old metal wall that catches your eye. The peeling paint color contrasting with underlying rust-laden patches could provide inspiration later, perhaps when designing an old, rusting robot. Ideas are fluid and something that catches your eye or interest can lead in unexpected directions, which is good. In fact, it is often when you connect two or more seemingly unrelated things in a way that hasn't been seen before that you come up with the most interesting, fresh ideas. It all starts with learning and observing as many different things as you can. Eventually some seemingly unrelated things will melt together in your mind for exciting new concepts. As an exercise, think of two things you really like, the more unrelated the better, and then see how you can bring them together in one design.

The creative process is often sparked by one thing that catches and holds your interest, something you can dwell on and think about.

But other times, ideas come randomly, at unexpected moments. Let yourself mull on these flashes of interest and see where they lead you. Think about what they might mean to you or others and how they might relate to other objects, animals, plants, colors, functions, or activities. Creativity is a flow; see how one idea can lead to another.

What follows are some examples of how I approached character design and what my inspirations were.

Javelina skull

Javelinas (also called collared peccaries) are distantly related to wild pigs and hippos, and live in the southwestern United States, where I am located.

I have a javelina skull and have always found it interesting that the upper and lower jaws both have large tusks that slide alongside each other so closely they actually seem to sharpen each other. (The bone along the base of the top tusk has a raised ridge with a flat area that the lower tusk tip rests on.) There are other, interesting shapes and grooves in the skull as well.

I really find this skull fascinating and wanted to design a creature using it as a template. First, I drew the skull itself, seeking to understand its anatomy. Then I let my imagination take over, experimenting, stretching, and exaggerating the various shapes to see what kind of creature I might make out of them. The end result was several different creatures. There's no wrong way to interpret and imagine, and if I'd continued, I probably would have come up with even more creatures.

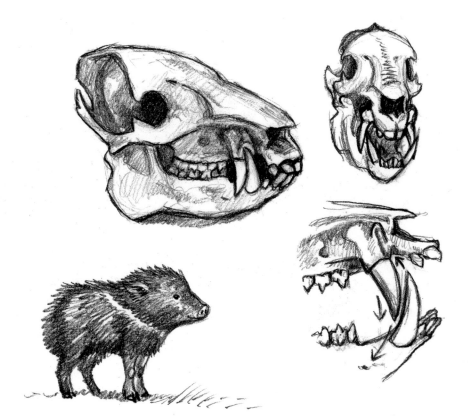

Javelina and skull. I drew the skull with a Palomino Blackwing drawing pencil as the skull sat before me. As I drew, I took note of the key shapes, mass, and curves.

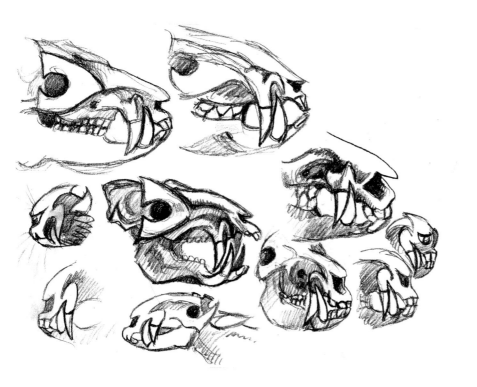

Here's a page from my drawing pad. I explored the shapes of the skull, exaggerating and defining the shapes I liked most. I didn't think too hard about any of it, simply allowing each sketch to develop as it wanted to. There are some recurring themes, like the prominent tusks, the ridge on the top base of the tusk, and the curving nasal groove. However, each drawing is somewhat different, as I emphasized different things I found interesting. Eventually, I focused on the nose and tusks, and started to see this almost cyclops, rounded head shape. I explored that further and wound up with a cat-like cyclops creature.

Once I'd spent some time just free-forming ideas, letting drawings develop as they may, I started to refine those ideas. The shapes were heading in three ways that I liked and decided to explore. One was the one-eyed cat-like creature, which I drew from various angles. Another was an almost goat- or antelope-like creature, which I decided needed horns and so added some wavy, gnarled ones that fit the creature. Finally, I tried to use some of the facial shapes of the dragon, which has skull-like armor plating on its head. These three different creature designs all came from one single source of inspiration: the javelina skull. I encourage you to try something like this. Find anything that is interesting to you visually and see what variations on it you can come up with. It can be an inanimate object, a living animal, a plant—anything that has an interesting shape. Even shapes in walls or wood can spark an idea.

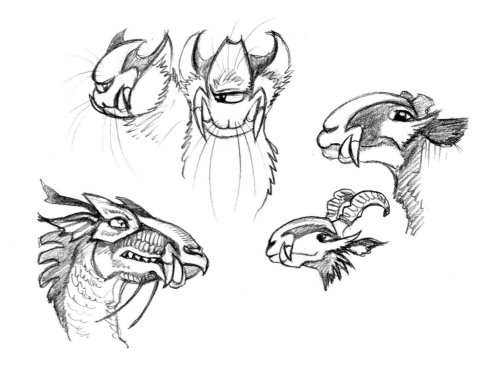

Pets

Many of us have or know pets, and they can provide endless sources of inspiration. Their behaviors and appearance can spark ideas. Their friendly familiarity gives us feelings of warmth and can make characters instantly appealing as they remind us of animals we know and love.

Many of us are at least familiar with salamanders and newts, like the tiger salamander pictured here. Even more of us have pet cats. Artists at Dreamworks Animation combined the likenesses of these two animals to make the memorable and appealing dragon named Toothless. Toothless's attitude and postures are rather like those of a pet cat, and it adds to his appeal, despite his more reptilian/amphibian outer appearance.

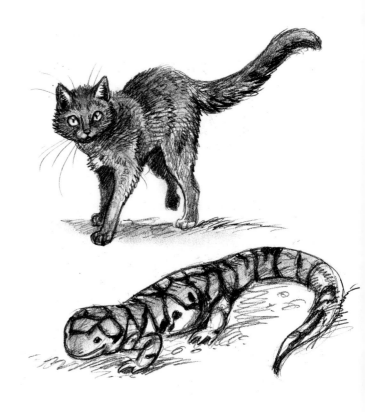

Dogs

I have two dogs named Sam and Pippin. They are loyal companions who inspire me with their beauty and can make me laugh with some of their behaviors. I get many different character ideas from them.

Here I'll brainstorm a few such inspirations and explain some of my thought processes as I designed.

Sam the German Shepherd Dog (top) and Pippin the Australian Kelpie.

One can take sources of inspiration and apply them in less obvious ways. Creating character designs from my pets doesn't mean I have to make them dogs, or even easily recognizable animals. I take inspiration from their relative shapes and colors. Sam is a big, furry, sable-colored shepherd (black-tipped guard hairs give him a dark, grizzled, salt-and-pepper appearance along his back). His black face is striking. His ears would be strikingly long, too, but he's managed to get both tips torn up over the years, giving him a rugged, postapocalyptic appearance. Pippin is a sleek, deep-chested, and athletic herding breed, red and tan, and she's super intelligent and fast. I can observe these qualities and apply them to characters that are not dogs. Take the bits that inspire you, and leave the rest.

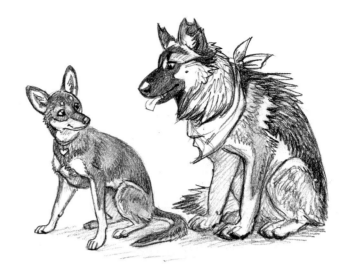

One thing I do is create cartoon characters based on my dogs. This is a fun creative exercise and makes you really *see* your pet and their physical appearance in more detail than you may have before. I went for friendly, appealing designs. Sam is much larger and blockier than Pippin, so I sought to emphasize that fact. I kept the lines and shapes fairly simple, so these designs could be used in something like animation or drawn repeatedly in a comic.

Here I decided to translate my dogs' qualities into horse characters. Sam became a big, blocky draft horse, with markings inspired by his real-life colors. I changed a few things. This is all from the imagination and doesn't have to perfectly match real life. I even gave Sam the horse some mottled markings not unlike his grizzled sable coloration in the spots along his back. Each spot adds to the

complexity of the design, but I didn't want it too complicated. Pippin became a sleek thoroughbred racehorse with thin legs and head and a deep chest. Her facial markings are inspired by the real-life Pippin, but not exactly. As always, I sought simplicity. Simplicity makes it easier to draw the same figure again and again.

ELEMENTS OF CHARACTER DESIGN

To create a memorable character design, one must give it a distinctive appearance that clearly conveys the character's personality. There are many elements to consider in working toward this goal. One must be mindful of archetypes and other audience expectations; communicate the character to the audience through shape, color, and accessories; and (sometimes) do something that surprises the audience and piques their interest through the unexpected. In this chapter, we'll look in detail at all these elements.

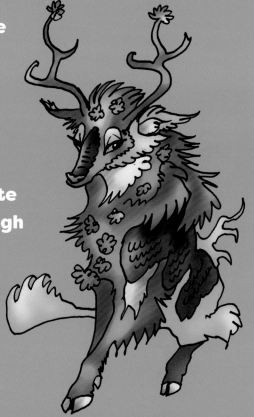

ARCHETYPES

A character archetype is a recurring, widely familiar type of person found in stories from cultures throughout the world. One is the **Hero Archetype**, first described by Professor Joseph Campbell in the Hero's journey. The Hero is usually a young, inexperienced person thrust into a story and forced to face adversity, assemble resources, find allies, and ultimately prevail over evil or some other problem.

Another familiar archetype is the **Teacher** or **Mage archetype**, a mentor who guides the Hero part of the way to the goal. These archetypes are powerful ones that most people know and recognize. People tend to relate to what they know, and instantly recognizing an archetype allows the audience to immediately identify with a character, or at least feel they are in some way familiar. This can be a good start to your story and your characters: create some archetypal characters that the audience can immediately understand and relate to, and let that lead you forward.

Hero

The **Hero** as a young, usually inexperienced protagonist is a standard of many stories. The Hero often starts out naive and underprepared, but always has some source of strength—a power, a special ability, or a sturdy spirit, mind, and heart—and as the story progresses, that strength will be mastered and used to defeat obstacle along the way.

The appearances of Heroes vary, but they are often associated with young, confident, and fiery energies. Many Heroes are designed using bright, primary colors, which help them stand out among the rest of the cast. A Hero is the type who is willing to go forth and take on a new day, no matter what it may bring. Hero forms usually skew toward friendly rounded shapes or sharp and fast triangular ones.

Here are two examples of heroic types. They're a little inexperienced but appealing and ready to start their respective journeys. Note how round and/or cute these individuals are, though the fox has a triangular appearance, which might indicate a slightly mischievous character.

Villain

The antagonist, aka the Villain, may be a character or it may be a
a force of nature or ignorance or some other situational obstacle
that is preventing the Hero and others from living their best lives.
As a character, the Villain is usually presented as wrong or evil,
but an interesting Villain usually has a reason for the things they
do, some logic to their "madness," even if they pursue that desire
in an evil way. The Villains are often heroes in their own minds,
but their actions indicate otherwise.

The Villain is often designed as very triangular/angular in
appearance, indicating a sly or sharp demeanor. A Villain can also
be comprised of large and square shapes that represent a phys-
ically threatening individual. Villains' colors are often dark but
can vary depending on story and region. Black, gray, green, and
purple are often, but not always, villainous colors.

Note how pointy or massive
these villains are. The kitsune
(fox) is all angles, while the
reptilian villain more square,
making him look solid and
powerful.

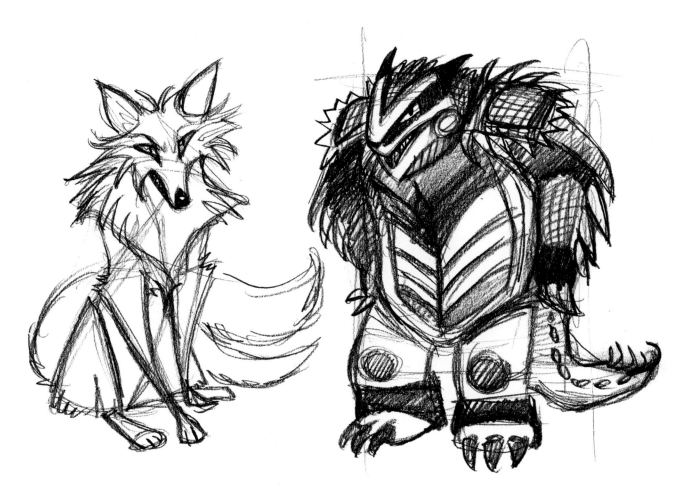

Sidekicks

A lot of times, if there are animal characters in a story at all, they will be **Sidekicks** or companions to the Hero—a faithful dog, magical cat, or wondrous fantasy creature that might serve as a guide or even a mascot for the story itself. Sidekicks may be important to the story, or placed there more to provide commentary as the story progresses, showing fear during scary scenes or being cute in happy scenes, like a Greek Chorus.

Sidekicks are often round and cute, familiar, comforting presences; or they are kooky or strange, and cute—always appealing enough to be a companion most would enjoy having around. Sidekick colors often complement the Hero's colors in some way, and they usually have a simple design, that complements but does not distract from the Hero.

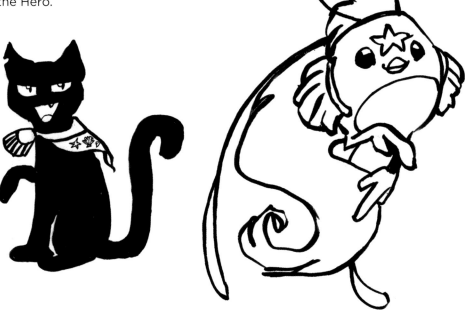

Note how many underlying shapes are round. The cat is more triangular, indicating perhaps a slightly edgier personality, yet still simple and cute. The dog and the fanciful bird, *Space Chicken*, a mascot for my manga-inspired comic *Spiral*, are both very cute and round. *Space Chicken* consists of many bright colors.

Caregiver

A **Caregiver** may be the Hero's friend or parent and is inevitably selfless and caring. Caregivers often watch out for the Hero and other characters, doing everything they can to keep everyone safe from harm or to heal the sick. A Caregiver may be a concerned friend who follows the Hero everywhere or perhaps the doting Mother or Father who is always there to welcome the Hero back home after an adventure.

Caregivers are often designed using soft, round shapes and soft colors like pink and other pastels that signify spring, flowers, Mother Nature, and growth.

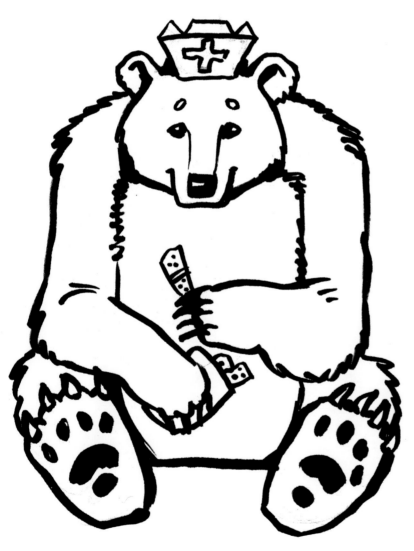

Note how this Caregiver bear is basically a solid rectangle, which lends a sense of stable support to her character.

Teacher / Mentor

This **Teacher/Mentor** character is the wise one who instructs the Hero (often a student) in skills needed to succeed. They are usually the elder in contrast to the Hero's youth. Experienced in life, they are often (but not always) more patient than the Hero and may have interesting and sometimes unconventional ways of teaching what Heroes and Students need to learn.

Teachers/Mentors are often associated with the colors of white, gray, or brown—pure and/or earthy colors that suggest a character that is more grounded or spiritual. A more spiritual or shamanic Teacher/Mentor may have accessories like bones, stones, jewelry, and other items that bring them power or inspiration.

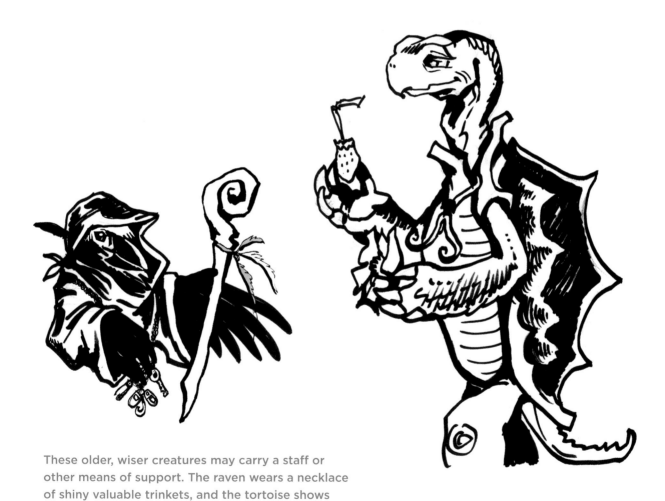

These older, wiser creatures may carry a staff or other means of support. The raven wears a necklace of shiny valuable trinkets, and the tortoise shows the lines and wrinkles of age often associated with wisdom. The tortoise also carries a cactus flower and fruit, perhaps ready to impart a lesson with these props.

Student / Child

Sometimes the **Student/Child**, often young and brash, is the Hero as well; archetypes can mingle. Or perhaps the Hero has a little brother or sister who fills the Student/Child role. Students and children experience the world with fresh, new eyes and innocence, learning through play.

Student/Child shapes are often round to reflect their innocence. They may be designed with bright or pastel colors.

Note how cute, round, and innocent these youngsters are, especially the bunny. The kitten is cute, but she has a blend of round and triangular shapes, giving her a slightly cute-with-an-edge look I will discuss later. Large eyes on any shape emphasize innocence and a sense of wonder.

Spirit / Guardian

The **Spirit/Guardian** can sometimes be the same character as the Teacher/Mentor, or it can be an entirely separate character, one that provides inspiration and lessons without directly teaching. It may be a forest guardian, an ancient god, or some other spirit or creature that inhabits a certain place or looks after it.

This archetype is often separated in some way from most of the cast, at least at first. It is usually different to some degree and may even be a rare sight or encounter. Encounters are often very memorable experiences and characters may come away changed in some way. Physically, Spirit/Guardians can be any shape, depending on the story. Some may be solid and round, a stable and sturdy presence such as Totoro in the Hayao Miyazaki movie *My Neighbor Totoro*, who is both soft and round and yet massive, strong; comforting and sort of scary at the same time! In another Miyazaki movie, *Spirited Away*, the dragon in the story is also a guardian spirit. However, he is more triangular, with a long nose and sharp scales and teeth.

Deer, elk, and the seasonal transformations of flowers inspired the design of this Guardian Forest Spirit. Flowers come and go with the seasons, as do an elk's antlers, and this spirit creature bears both those symbols in its design. The spirit is made of a variety of shapes, with triangular forms more apparent in the face and antlers, while the neck (and likely body) are more solid and rounded in structure, imparting a sense of stability despite the seasonal change.

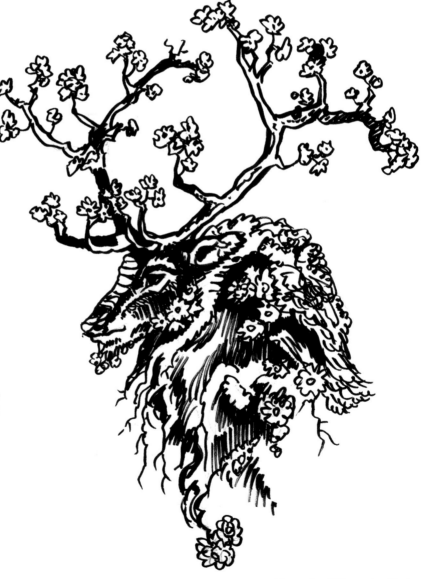

Magician

The **Magician** archetype can be mingled with other archetypes such as the Teacher or Guardian, but the Magician can fulfill other purposes in the story as well. Whatever their role, they astound most other characters with their knowledge of magic and other skills that boggle the mind. They are that one individual who seems to be able to not only grasp things most people don't understand, but also use that skill or knowledge at whim, astounding friends and fellows.

The Magician may lean toward a triangular physical shape, with a pointy wizard's hat, hawk-like nose, or some other striking feature. Often they reflect the blues and purples of the sky and spiritual world, or if evil, may be more likely to be green.

Note how this owl bears some very typical wizard accessories: a pointy hat and a magic wand.

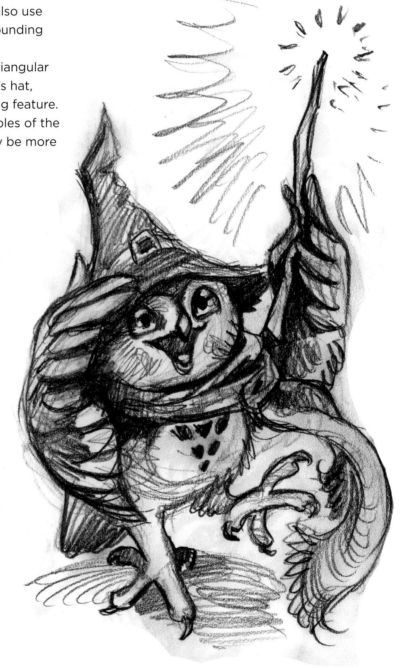

Ruler

Many stories will feature some sort of **Ruler** such as a King or Queen or leader. Rulers may be wise, watching over their lands and people with benevolence and thoughtfulness, or they may be despots, ruling with an iron fist and cruelty. The former may be the Hero or the one the Hero seeks to help, while the latter may turn out to be a Villain of the story, or at least one of the obstacles the Hero has to face during the journey.

A soft, kind Ruler might be designed with circles and ovals, while a cruel Ruler might be more triangular, and a stable never-faltering Ruler might have more squarish shapes. The shapes depend on the personality you give them.

I went for a steadfast and solid character design with this regal, lordly Lion. Here the square, steady King can be seen finished with pen and ink, holding his scepter, another symbol of royalty.

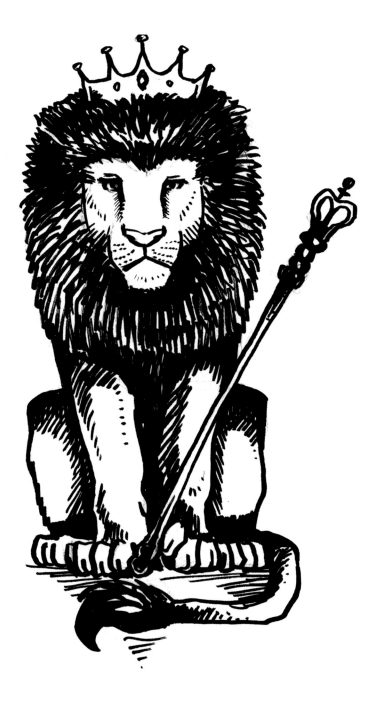

Joker / Trickster

The **Joker/Trickster** is a wild card who may be clownish, sly, or not quite what one would expect in that world. They may stand out in some way and it can often be difficult to tell what their true motivations are, at least at first. They often have a half-antagonistic, half-helpful approach toward the Hero and Sidekicks, creating problems for them but also helping them when they get in over their heads.

The Joker/Trickster is likely to be designed with pointy, triangular shapes and odd colors. If everyone else in the cast has primary colors and earthy tones, the Trickster type may stand out with purples, blacks, and greens.

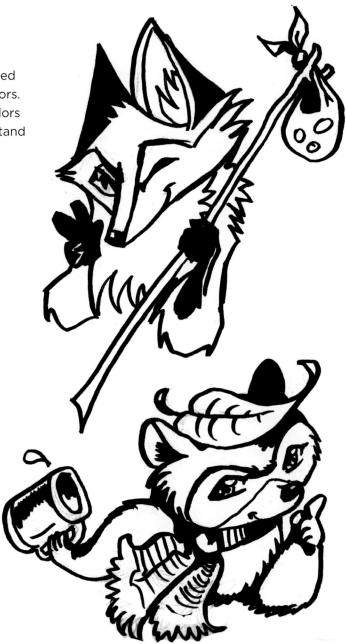

This fox and tanuki (raccoon dog) are both tricksters. They are probably up to no good, or perhaps they simply like to stir up trouble. If you're lucky, they'll turn out to have a soft spot in them somewhere and might even wind up helping your Heroes out in the end.

Rebel

The **Rebel** character is usually unsatisfied with the status quo or simply doesn't like being told what to do. The Rebel always questions authority and society's "norms." Rebels believe in their own strength and prefer to live their life the way they choose. They may also be rebelling against an oppressive regime, willing to fight to the death for what they believe is a noble cause.

Rebels are often triangular or solid and squarish in appearance, though a soft, round design could still work in some cases as a way to surprise the audience somewhat.

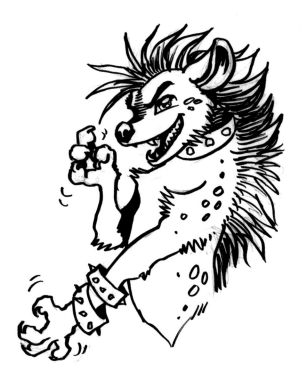

I drew this Hyena character as a rebel, complete with a "punk rock" mohawk hairstyle and leather, studded bands.

Lover

Lover characters are either in love or wish they were, and love dominates their thoughts and life. They pine away for their true love or are in love with someone and seek only to be with them forever! Lovers can be very giving and loving or they can be selfish. Sometimes, they are willing to sacrifice everything to be with the person they love, and this can lead to great romance, or great tragedy.

Lovers can be triangular, circular, or squarish, though softer and rounder might be most typical. They likely feature pink or red colorations, since those colors are often associated with romance.

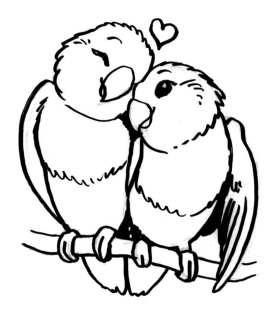

These Lovebirds are soft, round, and completely head over heels for each other.

PHYSICAL APPEARANCE

There are some universal things to keep in mind while designing a character. The elements of physical appearance—shape, color, and accessories—inform the viewer about the character's personality, intentions, and place in a story.

Body Shapes

The design of most famous characters can be broken down into three basic shapes: **circle**, **square**, and **triangle**. (We'll include oval with circle and rectangle with square.) Each shape brings with it certain expectations. A round, circular character seems softer and more approachable. A large, square, blocky character seems more stable or solid. An angular character seems sharper, possibly more intelligent, or perhaps more acerbic in personality or physicality. Use these generic shapes to inform your own character design and be sure to use a variety of shapes as you design. A character may have more than one shape in their design. Sometimes one shape may be the most prominent, while others are more subtle to hint at different aspects of a personality.

The more variety of dominant shapes in a cast of characters, the easier it is to tell characters apart and the more your cast stands out as something interesting.

Meanings of shapes

Triangle / Angular	Circular / Oval	Square / Rectangular
Sharp, severe, intelligent, extreme, clever, fast	Soft, gentle, cute, approachable, comfortable	Solid, dependable, sturdy, strong, slow

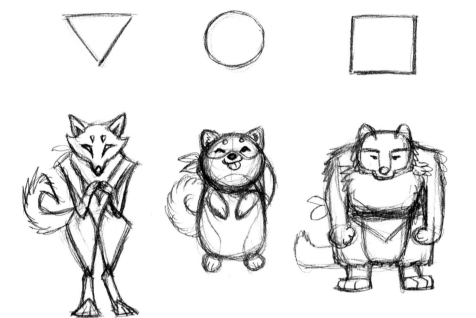

Here's an example of using various shapes to give different characteristics to the same basic animal—in this case, a Shiba Inu dog. The dog made of triangular shapes looks craftier, possibly sly, and likely fast in movement. The round dog, made of circles and ovals, looks like a cute, comforting fluff. The squarish dog looks heavy, stable, strong, and probably unimpressed.

Here are the three dogs in full color. Note that even though they all share the same basic colors, scarf accessory, and markings, they look quite different from one another due to their underlying shapes.

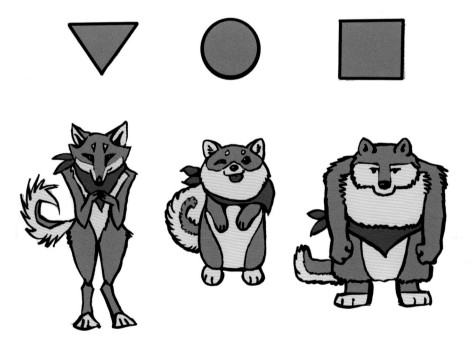

It is important to note that this discussion covers a basic look at shapes. Characters can be more complex depending on what they are designed for (comics, games, etc.). Many characters hold some characteristics of all three shapes, but often, one or two of the three basic shapes is dominant. The dominant shape can inform readers or video game players of their personality and purpose, with nuance and depth provided by the less-dominant shapes.

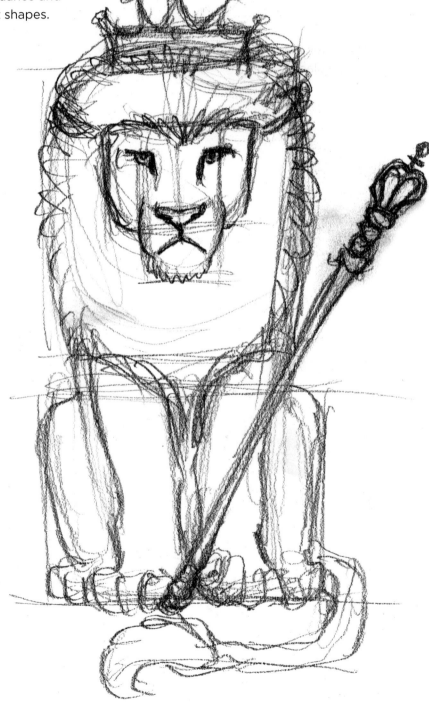

This early sketch of the King Lion (Ruler archetype) showcases the heavy use of squares and rectangles to illustrate the feeling that this character is solid, steady, and reliable.

Silhouettes

Silhouettes are another important factor in character design. Each character should have a clear and distinctive silhouette. Try darkening a picture of your charcter so that no detail shows, only their silhouette or outline. Is it easy to understand what you're looking at? Can you tell which character it is immediately? Can you tell what the character is doing?

Successful character designs have distinctive silhouettes that are recognizable even if all you see is a black outline.

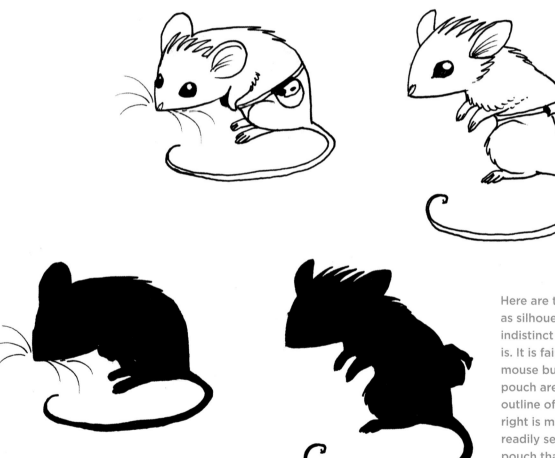

Here are the same two mice as silhouettes. Notice how indistinct the mouse on the left is. It is fairly easy to tell it is a mouse but the spiky hair and pouch aren't visible at all. The outline of the mouse on the right is much clearer. You can readily see the spiky hair and pouch that sets this individual apart, which makes it a more successful design.

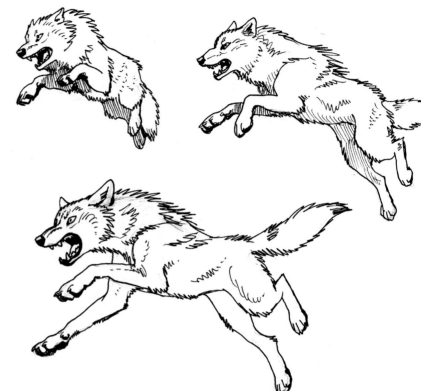

A clear and easily understandable outline is not only good for character design but your drawings as well. At the top left I drew a snarling wolf leaping at something. However, the silhouette of this wolf (below) is a bit of a blob that's not easy to read, making it hard for your audience to understand what is going on. I drew the same wolf leaping (top right), this time positioning the head, legs, and muzzle where their outlines are more easily seen. The wolf's action should be as understandable in a silhouette as in the full illustration. You can see in the top right that the wolf's legs are outstretched, mouth is open, and teeth bared. I pushed the action even further in the bottom wolf, on which I stretched and exaggerated its features and movements even more.

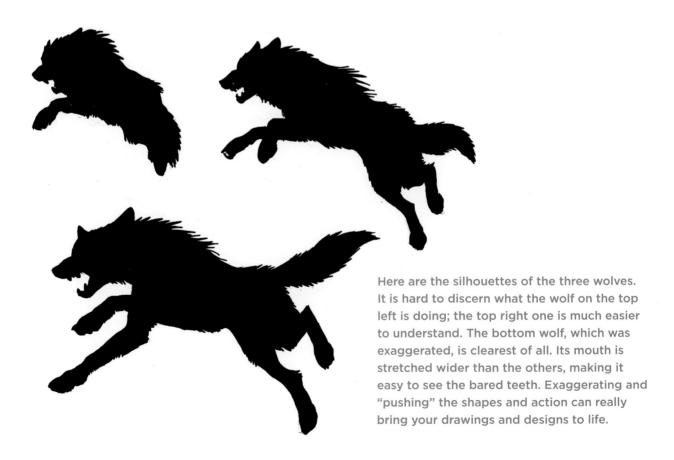

Here are the silhouettes of the three wolves. It is hard to discern what the wolf on the top left is doing; the top right one is much easier to understand. The bottom wolf, which was exaggerated, is clearest of all. Its mouth is stretched wider than the others, making it easy to see the bared teeth. Exaggerating and "pushing" the shapes and action can really bring your drawings and designs to life.

Color and color coding

Colors are another especially important factor in good character design. Colors invoke a mood and can suggest character traits as well as lead the eye to specific individuals and details. For example, main characters in a story will often feature primary colors (red, yellow, and blue). Red and yellow are especially popular, as these colors are bright, really pop, and catch the eye. Warm colors (yellow, orange, red) tend to push forward and read as bright and hot, while cool colors (blue, green, and purple) tend to recede and read as calm and quiet.

Each color has certain cultural meanings, too. It gets trickier here. Some colors, like blue, have a nearly universal positive association, but the meaning of others changes depending on the country. For instance, white is a symbol of purity and peace in many western cultures but in some Asian countries white symbolizes mourning, death, and bad luck. Red in western cultures is often a symbol of passion and love but in some places, such as Egypt, red can symbolize evil and destruction.

COMMON MEANINGS FOR COLOR FOUND IN MANY WESTERN CULTURES:

Red: Passion, love, sometimes anger or heat

Pink: Femininity, softness, healing

Orange: Optimism, warmth, fall themes

Yellow: Cheerful, sunny, happy; can be associated with cowardice

Green: Growth, healing, growing things, nature, wealth; can also be associated with jealousy and illness

Blue: Calm, serene, authoritative, trustworthy, water, sky; can also convey sadness

Purple: Royalty, sophistication, nobility, faith, intelligence, dignity

White: Purity, innocence, elegance, cleanliness; can also represent nothingness, blankness

Black: Bad luck, death, mourning; can also symbolize mystery, quiet, nighttime, and formality

You can make each character stand apart through non-color elements, like **hair**, **accessories**, and other **body features**, in addition to colors.

Here's a team of Fu Dogs, or Komainu (see page 157). In this black-and-white drawing, it's a bit hard to tell each individual apart. There are some clues, such as hairstyles and horns, but seeing them in color would make it easier to differentiate them. Stronger character design can be achieved by making sure each character is distinctive from the next, whether they are in color or not, but there are still some casts that feature colors as almost the only clues for who is who.

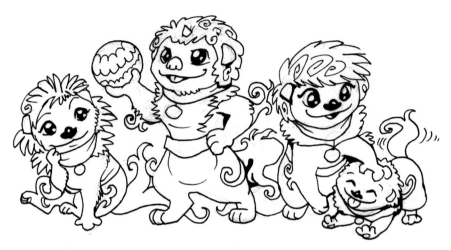

Here's the same team of Fu Dogs in color. You can see that each member of the team is color-coded. Can you tell something about them from the colors they wear? The dog in the middle in red, which symbolizes passion, is holding a magic ball and looks ready to take on whatever might come. The dog on the right wears yellow, which indicates a cheerful, optimistic disposition. The dog on the left wears blue, indicating a more serene, calm manner, and the thoughtful pose suggests this might be the intellectual of the group. The baby wears green, which could indicate he's still growing, or perhaps has jealous tendencies. (And sometimes, a color just looks nice contrasted against red, yellow, and blue.)

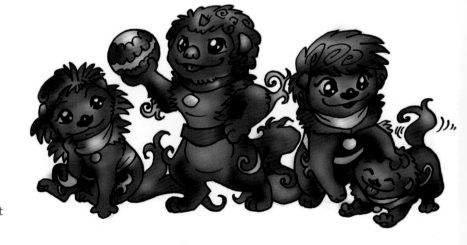

Color-coded teams are not uncommon. Think of the *Teenage Mutant Ninja Turtles*: Raphael wears red, which suggests his more hot-headed nature. Leonardo wears blue and is generally calmer and most often the leader (authority) of the team. Michelangelo's color is orange, which fits his cheerful, optimistic personality, and Donatello's purple represents his rational, intellectual nature.

Color can mean different things depending on context. Green is a color that can represent contradictory things, as both a symbol of illness, and also of healing and growing things. The meaning depends largely on the context in which one uses it.

I drew two kirin-like forest spirits, using the same main color in both—green. But I designed them with different objectives in mind. Can you tell which one is probably good and which may be evil or at least more of a threat? Both have some triangular shapes, but the spirit on the left is softened with rounded forms, flowers in its mane, and gentle eyes. The spirit on the right is much sharper, with numerous pointy appendages, angled hooves, and none of the visual clues of softness, like flowers. The creature on the right may once have been like the creature on the left until its forest was destroyed or polluted, and its rage twisted it into the creature you see now. I designed the one on the left with more colors, as well, making the right one's colors darker and starker. Overall, the one on the left appears softer and friendlier.

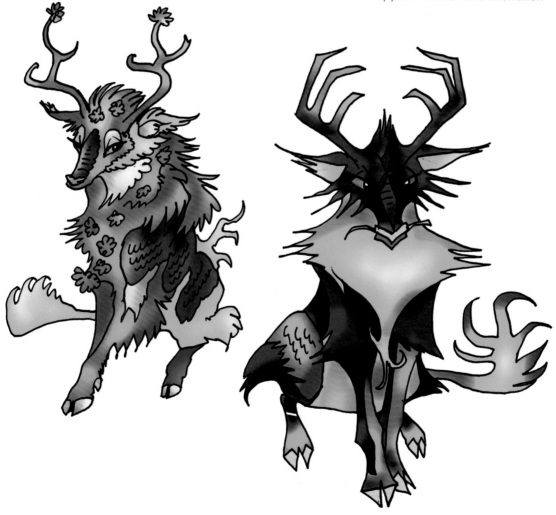

Clothing and Accessories

Clothing and accessories on manga-style animals can be simple or complex depending on your story's needs and are used to make an animal stand out in some way, whether it is a simple collar or bandana like a pet would wear, or some other accessory. If you are designing anthropomorphic animals, you can select from anything a human would normally wear. Use your imagination to take a "look" you like in humans and translate it to animals. If, for instance, you take the long, droopy ears of a lop-eared bunny a step further, imagine the ears pulled back to make a "ponytail" like a human might wear (below). A real rabbit wouldn't appreciate such a fashion statement, but in character design, anything can go. Just keep in mind that if this is a comic or other medium that will require many drawings, you'll need to draw that accessory multiple times, so keep it simple.

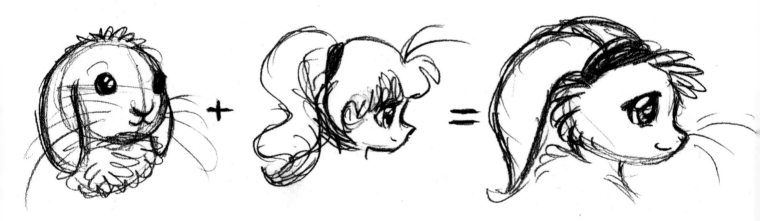

Here I've drawn a lop-eared rabbit wearing a "ponytail" like a human would.

Themes and Motifs

Themes and **Motifs** are recurring images or designs in your characters or stories, and they can materialize in several ways. For instance, say your story is set by the ocean and your cast of characters is from that seaside town. You can bedeck them all in coastal-themed clothing, jewelry, and other accessories. Maybe one wears seashell earrings, one has a nautical-themed shirt with a ship's anchor on the front, and one looks like a pirate, complete with peg leg and a parrot on their shoulder.

Similar characters can also be brought together with visual clues. Perhaps a bunch of characters are your background cast, there to give depth to the town but not a main focus. Consider making the majority of them big, squarish figures or perhaps small, rounded creatures that blend into the background. Your main cast would be designed with different shapes in order to make them stand out from the background. For whimsical, space-themed creatures for a video game, each creature would be different, but would also share some motifs, like star-shaped symbols on their heads, planet-like rings around their bodies, bright colors, and maybe a rounded, friendly shape for your more peaceful characters.

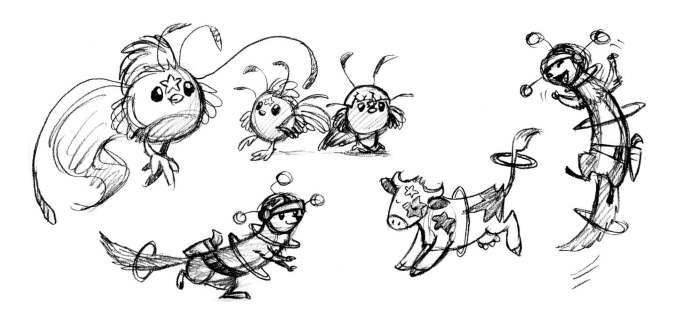

For my Space Chicken character, I designed a whole video-game-like world for his origins, complete with baby Space Chickens, Star Cows, and Space Weasels, all of which have different shapes. Space Chickens are round and cute, Star Cows blocky and rectangular. Space Weasels combine a softer, stretched oval shape with some triangular aspects, which hint at the fact that they are antagonists, always chasing after the Space Chickens. However, all creatures are unified with a cartoony space theme—the star and other astronomy-inspired shapes on the forehead, their coloring, the planetary-like rings around the cow and weasel, and the generally soft and simple shapes. They also all tend toward bright colors.

Expected vs. unexpected

You can use the audience's expectations to more firmly establish a character in their minds or to do something unexpected to surprise them. For example, many people associate small, soft, pink, round things as cute and harmless. If you were to subvert expectations, you might create a soft, pink, cute, round character that turns out to be the Villain in a shocking plot twist at the end of your story. One example of the unexpected that comes to mind is Jigglypuff from *Pokémon*—while the cute, round, pink Jigglypuff isn't really evil, it is provoked into a graffiti rampage because its songs put everyone to sleep!

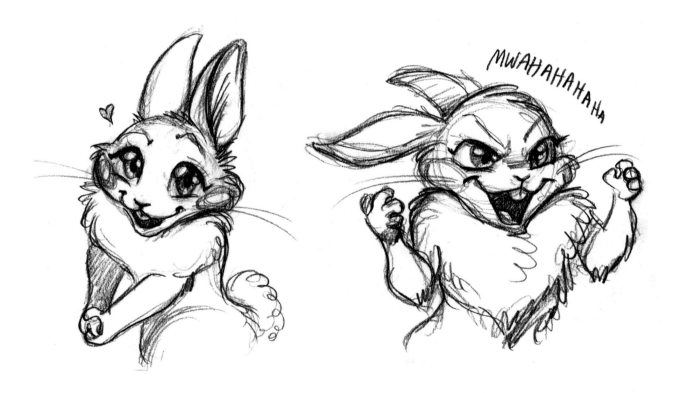

This bunny seems adorably cute and would likely be presumed innocent and sweet by her appearance on the left. But when she drops the cute act, she becomes the cackling Villain on the right.

Expected: A tough, fierce, and noble-looking gryphon, as one might expect to see in a heroic story. It stands in a rigid pose that looks fierce and ready but doesn't otherwise show a lot of individual character.

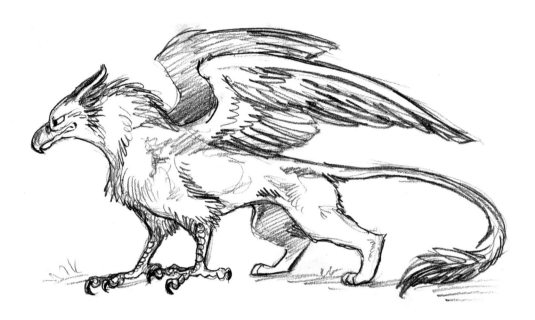

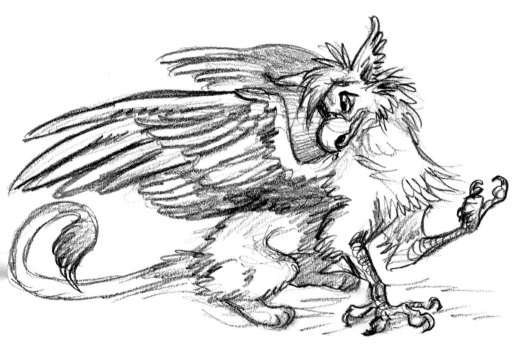

Unexpected: This awkward teenaged gryphon is still trying to figure out how to fly. This is Lydia, the main character in my manga-inspired story *Spiral*. She's a human girl changed into a gryphon and is trying to adapt. In this story, I took expectations of a fierce, capable monster and turned it around by making my gryphon as awkward and unsure as could be. Lydia's pose is completely different from the other gryphon. I've shown her as if she's conversing with someone, head tilted, one claw (hand) lifted as if gesturing, looking more like someone sitting and chatting than the typical, more beast-like stance and stare.

However, be mindful when going against audience expectations. If you stray from established norms, the audience may be confused if you have a cute, round character who is unexpectedly evil without any foundation in your story. You might have your other characters react with the same shocked disbelief as the audience when the plot twist is revealed. Or perhaps one character was suspicious all along and will have a moment of triumph as they cry, "See? I told you they couldn't be trusted!"

Audiences look for and relate to familiar things. Add unexpected elements to pique their curiosity. Take a character or storyline that seems familiar and add something different to it to make it stand out. Dreamwork's *How to Train Your Dragon* used such a tactic.

"A young Hero defends his village from a scary monster and earns the village peoples' praise" is a pretty common story through the ages. But, this movie subverted expectations by starting with a story with clichés that suddenly shift when the Hero finds that the monster—a dragon—is not a monster at all but simply a creature in need of help. This leads to an unexpected friendship and new relationships within a Viking-like village. Before *How to train Your Dragon* came along, the concepts of Vikings and dragon-riding were not commonly placed together. However, the movie brought those two elements together. What two or three different things can you combine to create something new that hasn't quite been seen before?

Note the difference between these cute baby foxes. The one on the left is a standard cute type—soft, rounded, and probably as innocent as it looks. The kit on the right, however, has a slight edge—cute, but likely mischievous, too, as suggested by the sharp elements: one small snaggletooth, slanted eyes, and even the more cat-like vertical pupils (which foxes do have). He's not a Villain, but he might just play a trick on you!

Cute vs. cute with an edge

Cute animals are a staple in many stories, comics, movies, and games, appealing to a large number of people. Each story is different, however, and there are some creators who largely avoid anything they feel is too cute while others can't get enough cuteness factor. Some stories are made to be bright, adorable, and cheerful, and cute animals fit easily into those settings and stories.

The cute character is commonly round, soft, and innocent-looking and appeals to (most) people. We humans tend to respond to anything with large eyes, comparatively larger heads, and soft, rounded features like those found in babies, and we are protective and positive toward them. Youngsters and children are usually drawn in a cute manner.

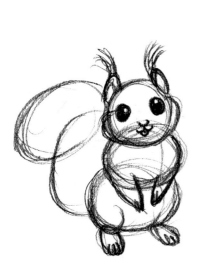

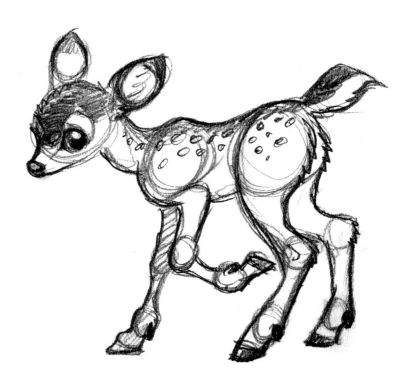

I've drawn two cute animals: a fawn and squirrel. To keep them as cute as possible, I've used a majority of soft, round shapes in their design. Their eyes, and the fawn's spots, are round, their bodies comprised of circles and ovals. Even their ears are mostly rounded.

If you want a cute character but don't feel something completely adorable really fits in your story, consider "cute with an edge"—a cute character that has a slight edginess to it. Something in its design, whether a more angular build or a mischievous expression on its face, indicates this cute character can still surprise you, maybe even trick you. They're cute, but you may not want to let your guard down around them.

Sometimes cute becomes a parody of itself in character design, as mentioned in the Expected vs. Unexpected section (page 52). Characters may be designed with an ironic element: incredibly cute with big eyes and proportionally large heads who turn out to be the Villain at the end, or are otherwise unpleasant despite the superficially cute outward appearance.

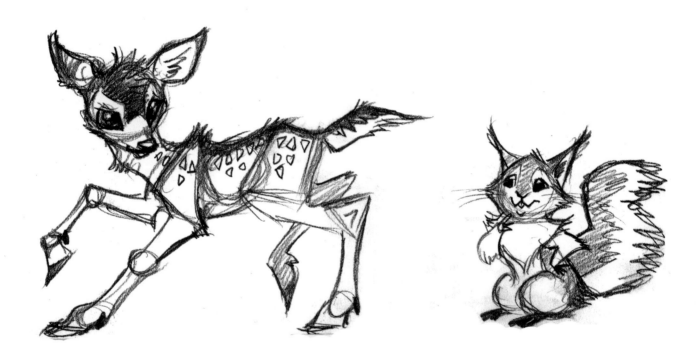

Another cute squirrel and deer fawn, but this time triangular shapes dominate their design. The squirrel's chest is triangular, its ears very pointed, tail more jagged in appearance, and even the eyes are more angular. The fawn's body consists of a triangular shoulder, squarish hindquarter, and triangular spots as well as many jagged tufts of hair that give it an overall pointier appearance. There are still some soft, round shapes, but overall these two look more mischievous.

PUTTING THIS ALL TOGETHER: CREATING AN APPEALING AND MEMORABLE CHARACTER

There's a saying I like: First you have to know the rules in order to break them. All the rules listed here can be broken, but first you'll do well to learn what those rules are and why they usually work and have been part of human culture and symbology for ages.

Learn what your audience expects. Then you can decide whether to bend or break those expectations. When done right, you can create new and unexpected twists for your audience to discover. How is it done right? That is subjective, but consider both your and your audience's enjoyment. A well-thought-out twist or bending of rules can leave your audience excited, pleased, and eager to see what comes next. Include them in the journey of discovery, perhaps throw out a foreshadowing or other clues that things may not be quite as they seem, through visual clues or character reactions/actions. If your audience is having fun, even if they have to work to figure things out, your designs and your story are a success. But you must also enjoy all of it. If you don't enjoy it, nobody else will.

What makes a character appealing? This is highly subjective since everyone has different tastes. However, some traits have broad appeal and there are characters that many people really like. The most obvious example is a cute character. As a species, we tend to respond positively to anything that has the innocent characteristics of a baby: big eyes, lack of guile, and awkward, clumsy movements. Many popular characters in movies, video games, and manga are cute. There are

also many cute-with-an-edge characters like Sonic the Hedgehog. He has generally cute proportions but his smirk and furrowed brows hint at his cocky, not-so-innocent attitude. Still, he and most of his companions have the "cute" proportions of large heads and relatively huge eyes. Seeing and connecting to expressive eyes and faces generates a quick bond between character and viewer.

But, not all appealing character designs fall into the "cute" category. Sometimes appeal comes from other bonds between character and viewer. As human beings, we tend to like what we can relate to, what we understand. Even if a character is not especially cute, if we can relate easily to something about that character, we may respond very positively to it. Sometimes that is a sense of power. A character that comes across as powerful may appeal to many because we are often drawn to power and charisma. If the character has some other feature we can pick up on and relate to quickly, we can form an instant bond. Perhaps the character is an eager explorer. Many of us can relate to that joyous curiosity about the world around us. Others may be drawn to dark, brooding characters that reflect the traits of a person who stands back, observing a complicated world and holding on to defenses that

may protect them from that world. Things we relate to are also things we tend to remember. What kinds of things do you relate to? Odds are others will relate to them as well.

Successful character design will focus on some of those relatable traits and meld them together into a harmonious, cohesive whole that is easily understood by the viewer. Shapes, colors, and themes found within the character's design should all work together into that unified whole. Unity, interest, and our ability to relate to it are what make a character design memorable and appealing.

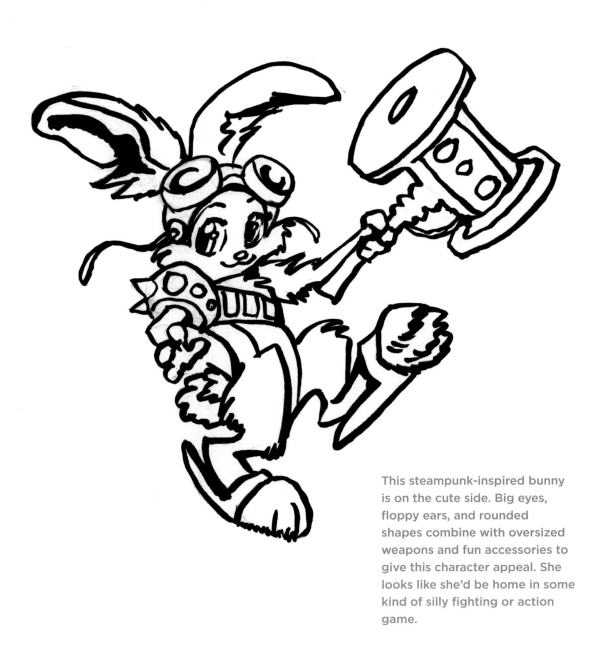

This steampunk-inspired bunny is on the cute side. Big eyes, floppy ears, and rounded shapes combine with oversized weapons and fun accessories to give this character appeal. She looks like she'd be home in some kind of silly fighting or action game.

This creature isn't as typically cute as something like the steampunk bunny, but her rounded body and somewhat sad expression invite the viewer to see her as not quite threatening, despite her horns and spikes. Her expression could invite sympathy and her small butterfly-like friend might invite curiosity—who is she, why is she holding this small critter on her finger, and why does she look sad? When the audience puts themselves into the character's shoes, asking questions like these, they are well on their way to finding something to which they can relate.

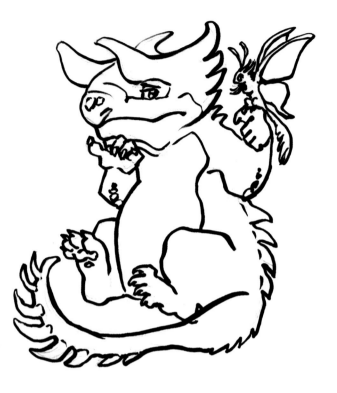

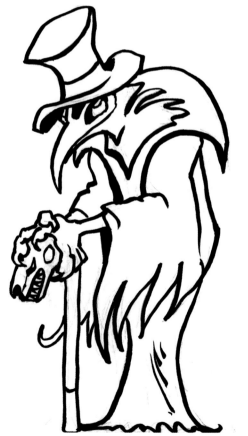

This character isn't cute. In fact, it has a slightly creepy feel to it like the old-time plague doctors with their bird-like masks. But this character possesses some appeal of a different sort. It may not seem cuddly or friendly, but it does encourage the viewer to wonder who or what it is and why it wears that mask. Something like a mask or armor, that hides a face or body, can raise questions about what the character might look like underneath. Things that provide a strong reaction and raise questions in the audience's mind are the things that the audience may find most memorable. Memorable, interesting: these things add appeal even beyond the usual "cute and friendly."

BASICS OF DRAWING & CREATING ANIMAL CHARACTERS

In this chapter we will explore how you can use the foundations of studio art studies to develop and flesh out your characters. We'll cover all the essentials from basic shapes to character types to actual drawings of manga-style animals.

DRAWING BASICS

There are so many ways to draw an animal manga-style! It can look realistic or extremely cartoon-like, be charmingly simple in design or captivate viewers with its complex beauty or power. It's up to you to decide what best fits the story or art you want to create.

Four or more legs

Except for birds and invertebrates, most realistic animals have the basic four-legged structure: two front legs attached to the front of the body and two hind legs at the back. (Invertebrates like insects may have many more than four legs.) Many manga and video game animal designs lean toward the simple leg versions, since simple is easier to draw or animate again and again, but sometimes the story, art, or game calls for something more complex and realistic.

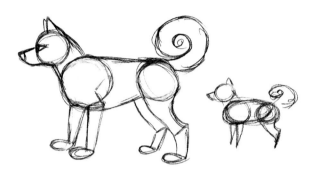

The standard four-legged animal features are: a head, front legs, chest and abdomen, and hind legs and tail, which you can portray with a series of circles and ovals, as shown.

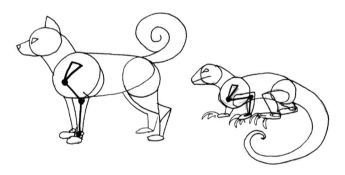

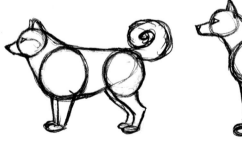

You can vary the proportions of these features from animal to animal, as with the dog at left and the lizard right. I indicated the shoulder blade and the basic front leg bones of each animal. Note that the lizard's legs are more squat and closer to the ground than those of the dog. When you change the length, position, and proportions of each feature you change the animal species.

Changing proportions even among the same species can be used to differentiate individual characters, too. Note how the dog on the left has a deep chest and shorter legs while the other dog has an elongated snout, long legs, and a thin base of the tail.

Simplified bodies

You can simplify a character even further, to a basic shape that makes the creature easy to read and easy to draw over and over. The amount of detail you include falls largely to your individual taste. A basic knowledge of animal anatomy (see pages 78–79) will broaden your understanding of what looks plausible vs. lazy and half done. Knowing how actual anatomy works will help you to distill the essence of a form with just a few strokes of your pen or pencil.

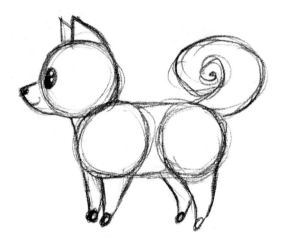

This dog starts with three circles. Draw the legs as simple triangles with small ovals or circles for paws, or even no paws at all. The idea is to use as few angles and details as possible, just enough to give the body its form.

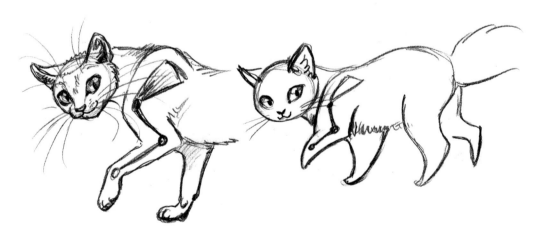

To simplify a complex shape, such as the front leg of a cat, reduce it to its underlying skeletal essence, placing only that essence on the page (or screen). The leg has joints and angles, places where muscles bulge (the shoulder) or an elbow juts out sharply, as the cat on the left illustrates. Create an even simpler shape that conveys the same gesture but with far fewer lines by reducing the amount of detail, as with the cat on the right.

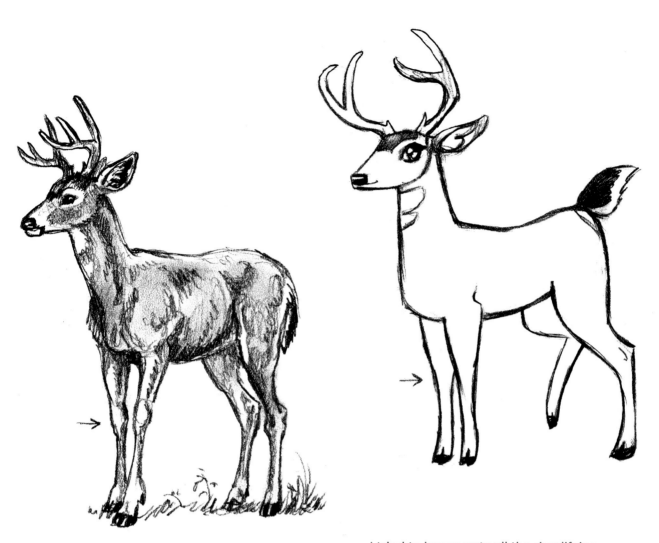

Here I worked on simplifying this blacktail deer to its essence. Some of the key features I wanted to exaggerate or isolate included the deer's long neck, long muzzle, somewhat rectangular body, antlers, hooves, long legs, and short but bushy tail.

I tried to incorporate all the simplifying techniques we've discussed in this new, simplified deer design. I used the fewest lines possible, while still conveying the things I needed to. The legs are very simple. The top parts of the front legs are still thicker than they are below where the wrist joint would be (the big knobby joint visible on the more realistic deer at left). I didn't render this joint on the simplified deer, but indicated it in the way the legs taper below the halfway point. (Arrows point to the joints on both drawings.) I drew as few points on the antlers as possible to indicate the general shape. The body is boxy and rectangular and has nowhere near the detail of the realistic deer. Everything is as simple as I could make it.

How to draw a simple four-legged animal step by step

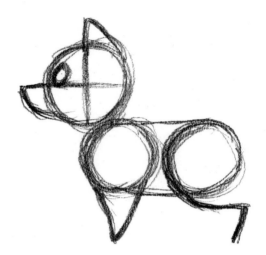

1 Draw a circle for the head, then two slightly smaller circles, one below and slightly to the right of the head for the chest, the other to the right of the chest for the hips. Divide the head circle into four equal quadrants to help with face and head proportions.

2 Add a muzzle to the left of the head circle, out and down from the horizontal line in the center. Add an ear, drawing up from the vertical center line and curving down along the back of the head. Draw an oval for the eye. Connect the chest and hips with parallel horizontal lines for the back and stomach. Draw the front leg as a triangular shape, adding a very subtle curve forward at the bottom tip. Draw the hind leg, sweeping down and out from the hip circle and sharply turning downward at the heel.

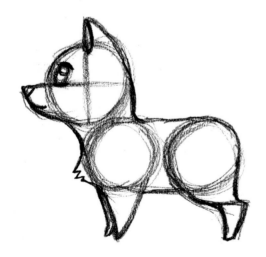

3 Add a mouth, nose, and pupil and highlight to the eye. Define the top and bottom eyelashes. Draw a teardrop shape on the front (left) of the ear to indicate the inner ear. Draw a tuft of hair on the chest and add lines for the neck. Add an outline of the far front leg. Complete the hind leg by connecting the heel to the rump with a curved line, and then add the hind foot, bringing the line up to meet the hind leg.

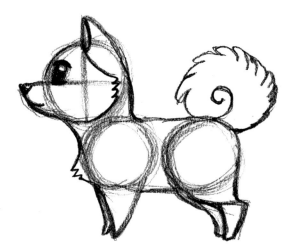

4 To finish the dog, shade in the pupil; draw a cheek ruff, sweeping a line down and right from the base of the ear to the horizontal line in the head circle; then draw some shaggy lines for fur, as shown, before sweeping back down and left to meet the curve of the jaw. Add the far hind leg and a tail.

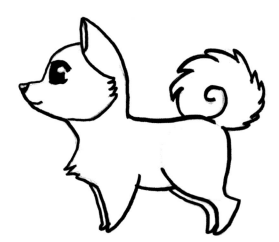

5 When you finish the drawing, erase guidelines and pencil lines as needed.

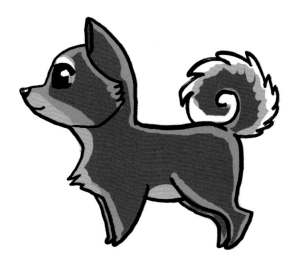

6 The finished dog character, in color.

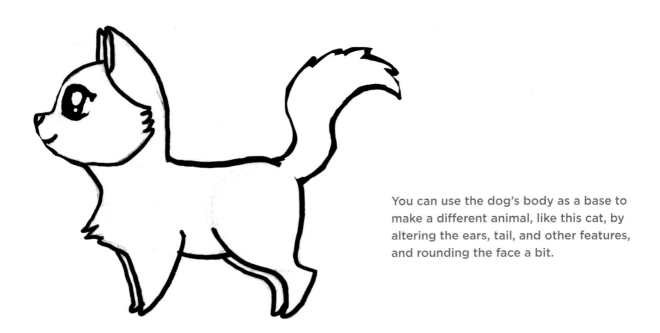

You can use the dog's body as a base to make a different animal, like this cat, by altering the ears, tail, and other features, and rounding the face a bit.

The cat in color.

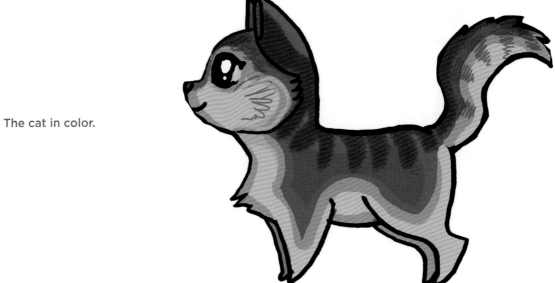

Multiple Legs

Insects and other invertebrates, like spiders, caterpillars, and centipedes, usually have many more than four legs. The invertebrate world alone is full of fascinating and otherworldly creatures ready to provide all sorts of inspiration for character designs.

Insect legs (and wings) are generally attached to the thorax (body), with at least one pair in front, two in the middle, and a rear pair supporting the abdomen in the back. Spiders, which are arachnids not insects, have eight legs total, four on each side of their thorax, along with pincer-like pedipalps at the base of the head that almost look like short legs. Creatures like caterpillars have "false legs" or prolegs on their abdomen. Other invertebrates such as centipedes can have multiple legs along their entire body.

Realistic and detailed characters

Some creature designs include a lot of detail to create a sense of realism, whether the animal is a real animal or one born of fantasy. In the following designs, artists took time to add lots of anatomical details, feathers, fur, or scales, and other artistic flair.

Adding fur to this basic dog highlights its anatomical details and gives it more realism and dimension.

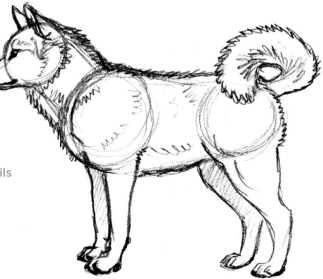

Two legs

Two legs are often associated with either a human-like stance or birds, as shown in the drawings that follow.

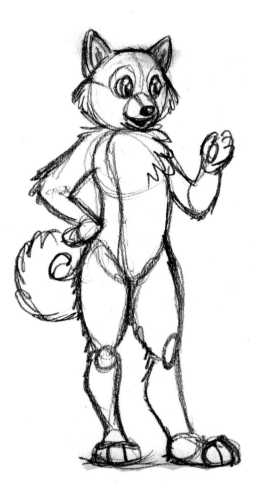

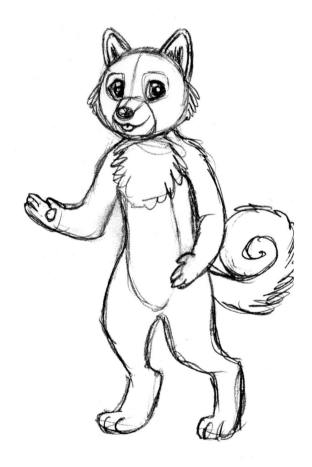

These characters have human-like bodies that stand on two legs. Their forms are relatively simple and can easily provide the base for a variety of anthropomorphic (human-like) characters. Some artists like to draw figures with more human-like legs (left), and others prefer a digitigrade stance with only the animal's toes, but not their heels, on the ground (right).

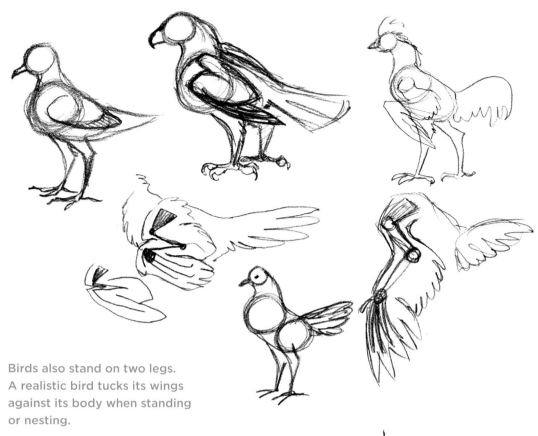

Birds also stand on two legs. A realistic bird tucks its wings against its body when standing or nesting.

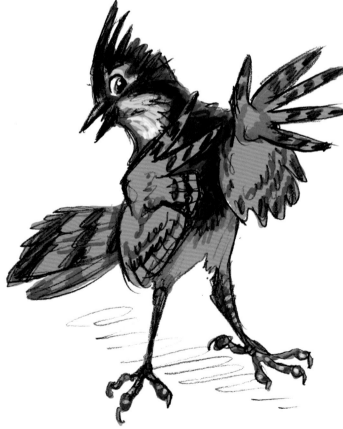

In contrast, this Steller's Jay shows how birds' wings can be drawn much like human arms, with the primary feathers (wing tips) acting like a human hand.

How to draw a simple bird shape step by step

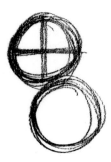

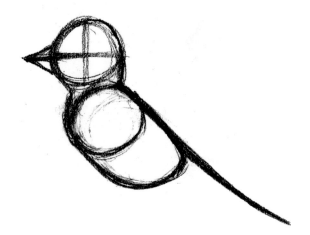

1 Draw a circle for the head, then a similarly sized circle slightly to the right and below it for the chest. Draw lines dividing the head circle into four equal quadrants for proportion guides.

2 Add a bisected triangle to the left side of the head for the beak, centering it on the head circle's horizontal line. Elongate the body circle into an oval, then draw a somewhat flat line down the back of the oval, sweeping the line out at the bottom to indicate the tail.

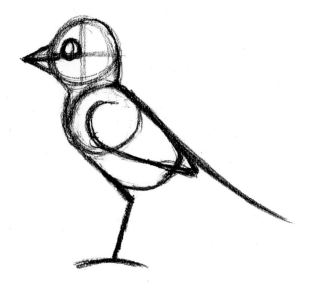

3 Draw a circle for the eye and add a pupil. To draw the far leg, follow the front of the body down the belly, extending the line just a bit before bending it sharply toward the ground and ending with a gently curved horizontal line indicating the foot. Draw the wing using a fishhook shape, as shown, curving around the center of the chest circle and extending slightly past the rear of the body, making a sharp tip sticking out at the bottom.

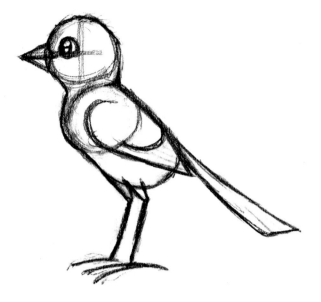

4 Define the beak into a point like a diamond where it sits on the head. Add a highlight to the eye. Draw an arc shape on the wing from the back to the chest circle, as shown. This is the fold in the wing. Draw the leg. Make the tops of the legs triangular with the wide angles closest to the body to create some thickness before the joint bends sharply. The two leg tops should form something like a "W" slanted to the left, as shown. Draw the near foot with two forward-facing lines for toes.

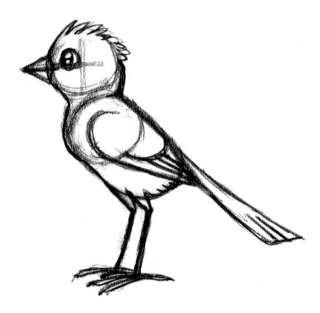

5 Add some squiggly lines indicating feathers on the top of the head and some straight lines along the tail to indicate tail feathers. Draw straight lines coming from under the fold of the wing down to the tip to indicate the primary, or wing tip feathers. Add a third, back toe to the near foot, behind the previous two; then flesh out the toes and legs as needed. More squiggly lines along the rear can add a feathery appearance to the body.

6 Clean up the final lines, then erase or delete pencils or guidelines as needed.

CHIBIS, MASCOTS, AND BABY TYPES

Cute characters with baby-like proportions are common in anime and manga. Chibi features include proportionally large heads, big (sometimes huge) eyes, relatively small or tiny bodies, and simplified features and limbs. Mascots have a similar simplicity, but not the hugely exaggerated eyes and tiny bodies that chibis do. Babies are similar to chibis and mascots, but have less exaggerated features that will eventually grow to adult proportions. You can change the animal species by adjusting the shapes, placement, and proportions of ears, nose, tail, and other features.

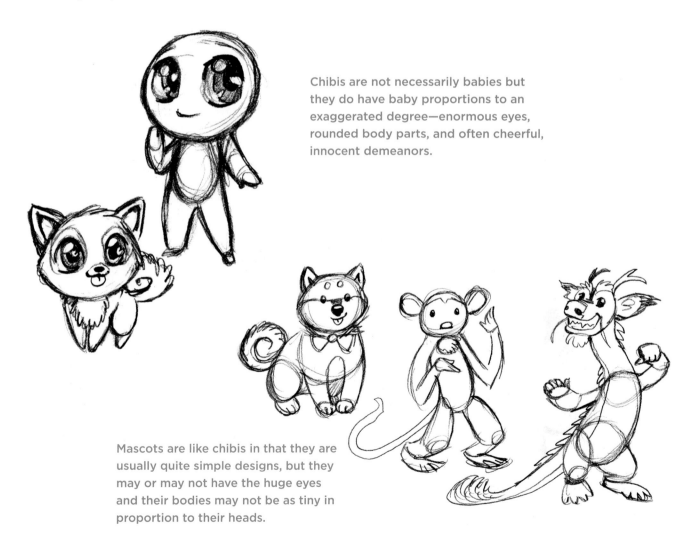

Chibis are not necessarily babies but they do have baby proportions to an exaggerated degree—enormous eyes, rounded body parts, and often cheerful, innocent demeanors.

Mascots are like chibis in that they are usually quite simple designs, but they may or may not have the huge eyes and their bodies may not be as tiny in proportion to their heads.

How to draw a chibi step by step

1 Draw a circle for the head. This will be about half the figure. To help you with facial proportions, draw lines dividing the head into four equal quadrants, curving the vertical line slightly to the right and adding a subtle up-curve to the horizontal line. The figure is facing slightly to the viewer's right. Draw a small vertical oval for the body, about the same length as and half the width of the head circle.

2 Draw the eyes, making them huge. Keep a space of about one eye width between the two eyes (as shown by the dotted circle). Use the vertical and horizontal dividing lines of the head circle as a guide. The near eye, on your left, should be slightly larger than the far eye. The horizontal line should run through the center of each eye. Next add the front/top legs as simple tapering tubes that end in a point. Add the suggestion of hands with a tiny oval or circle at the tip.

3 Add pupils, then highlights to the eyes. One highlight should be bigger than the rest; I put this on top and then add one or two smaller highlights below. Define the eyelashes on the top of the eyes by thickening and lengthening the line slightly. Add a smiling mouth centered between the bottom of the eyes. Draw the legs, which are short triangular tubes that taper down to a point.

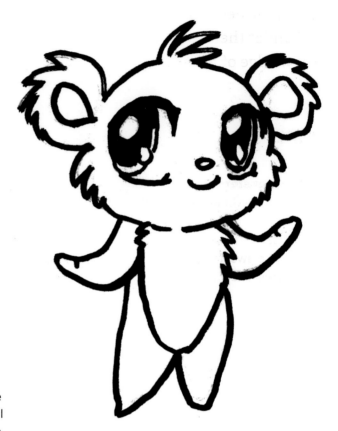

4 Shade in the pupils and add a little circle nose. Draw ears in the desired shape (in this case they're bear ears). Note how I used the horizontal line of the head circle as the base from which the ears curve up and circle around back to the head a bit above the eyes. Add features like cheek ruffs and tufts of hair on the head.

5 Finish the drawing, putting in final lines and then erasing or deleting pencil marks as needed.

MONSTERS, CUTE AND FIERCE

Cute monsters like Pokémon have taken the world by storm. Their simple and appealing designs and often bright colors catch the eye and charm those who fall under their spell. The key to the charm of this character type is simplicity. A knowledge of anatomy and the amazing variety of the real world of nature will help you in your efforts to design these creatures. Choose a basic idea to tackle, such as a salamander or a monkey, then work on simplifying that form into an engaging and easily understood creature.

Fierce monsters, brimming with tooth and claw, are anything but cute! Frightening monsters are usually, but not always, drawn more realistically. Their proportions are more realistic and claws, fangs, and other spiky, sharp details will likely be on ample display.

This cute kirin and ghostly firecat both have proportionally large eyes and heads, short limbs, and rounded bodies that add appeal and cuteness.

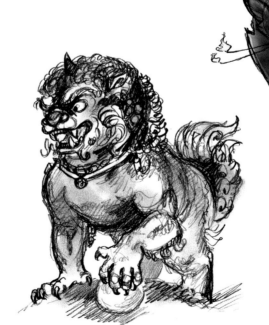

Both this nightmare and the fu dog display prominent teeth, furrowed brows, flaring nostrils, and strong claws or hooves ready to stomp or swipe. Both are drawn more realistically than the "cute" monsters at right.

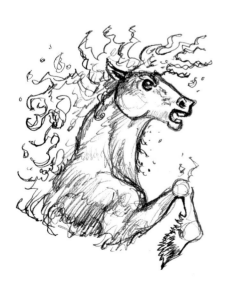

APPLYING BODY LANGUAGE AND EXPRESSION TO ANIMALS

How do you make animals emote? In a lot of cases, it's a matter of taking a human expression or gesture and translating that into an animal form.

The bird mimics the human's gesture with exaggerated and simplified shapes to convey the same expression and motion but with wings and a beak instead of arms and a face. Note how the hands and fingers translate into the long wing tips, or primary feathers. A real bird couldn't separate its wing tips like this, but in a drawing it can. Exaggeration while maintaining plausibility helps provide a suspension of disbelief for your audience, making things that couldn't happen in reality look believable. Wing tips look similar enough to fingers that having them operate like fingers is believable, if not realistic, especially with a more cartoon-like figure like this. Likewise with the wing tips on the other side that smack against the head to enhance the expression of excitement and urgency.

The somewhat bored human figure on top is mimicked by the lion below. Note how the lion's paws are in the same position as the human's hands. The lion's dewclaw (the fifth toe found up above the main paw) is equivalent to a thumb, and that's how I've placed it here. Knowing how human and animal anatomy work really helps when you're doing drawings like these because you see so many correlations and parallels. I've added little arrow markers to the drawing indicating similarities between the two figures, like the thumb and dewclaw and the crook of the top human finger (lion toe) and how it separates from the other fingers or toes.

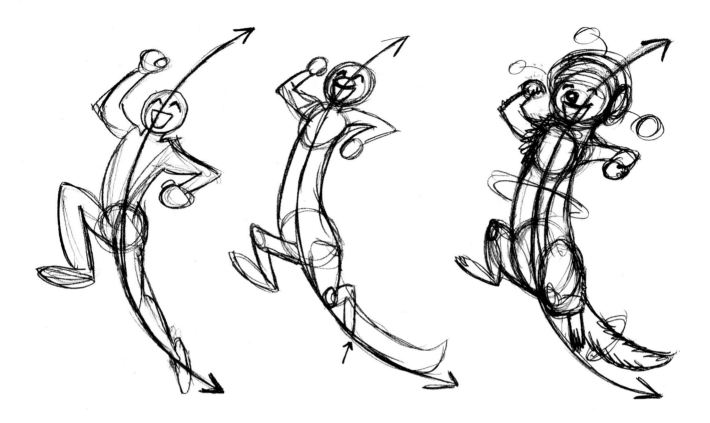

On the left is a basic human-like figure, jumping for joy. The arrow follows the curved sweep of the figure's **action line** (the basic gesture or motion a figure is displaying). Every line in the figure is drawn along the line of that curve, supporting and enhancing the basic gesture of a sweeping arc shooting into the air and reinforcing the sense of upward motion. The more lines that echo that motion, the stronger the perception of that motion.

I changed the proportions of the middle figure into more exaggerated ones that reflect the weasel-like body of the character I'm designing— lengthened torso, shortened and simplified limbs, and an added tail. I drew a second arrow pointing to the place where the foot meets the sweep of the tail's underside. While both reinforce the sweep of the action line, the way they meet and end at the same exact spot makes the foot a bit hard to see.

On the right, I've further refined the middle figure, echoing its shape and gestures, into Space Weasel. Note how he mimics the motion of the human on the left while featuring the more weasel-like proportions of the middle figure. The blend of recognizable human gesture with weasel proportions, especially in such a cartoonish figure, makes this unrealistic character seem plausible, believable enough for the audience to accept it. Note also how I moved the tail back a bit so that the toes of the foot protrude away from the area of the tail and are now much easier to see.

MONSTERS AND OTHER CREATURES: HOW TO CREATE A CREATURE FROM YOUR IMAGINATION

Once you have learned and practiced basic drawing skills and added to them by studying things like anatomy, habitats, and animal behaviors, only your imagination will limit the creatures you can create.

The importance of studying anatomy

The number one thing you can do to improve your drawing skills is study anatomy. Learn how bones support and affect muscles, which support and affect the outer skin and appearance. Many animals, from mammals to birds to reptiles, share a similar basic structure of bone and muscle, and once you know this basic building block your art will get stronger. Just knowing the basics will help you in visualizing creatures' bodies both real and imagined. Study skeletons, human or animal, draw from a model skeleton if you have access to one, and study anatomical drawings. You can even find 3D skeletons online that you can turn and view from multiple angles. (Search something like "3D animal skeleton model.")

You can also take parts of a skeleton and exaggerate them to emphasize certain features of your choosing. Maybe you want something dog-like, but the creature in your mind is extremely fast and graceful. So perhaps you draw something like a greyhound, but exaggerate to make the leg bones even longer, the chest/rib cage even deeper, etc., and create your own new, very graceful, and fast-looking beast.

In this dog skeleton you can see all the basics: rib cage, spinal cord, front limbs, hind limbs, skull, and tail. Humans have the same components (except no real tail to speak of), just aligned vertically rather than horizontally. Dogs and humans also share many equivalent features. A dog's front limbs are kind of like our arms, their paws like our hands, etc. When you know that, say, a dog's front paw is equivalent to a human hand, you can draw a cartoonish dog using its front paws like a human hand and have it look believable.

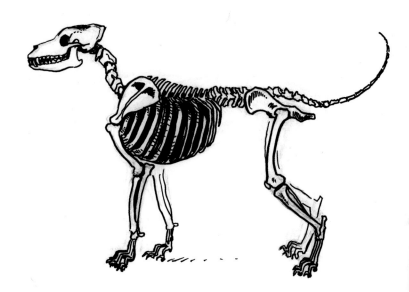

This creepy creature shows the same dog skeleton, this time covered with muscles. Muscles affect how the animal moves and what its skin, fur, scales, or whatever looks like over them. Of course, you could take this particular anatomy lesson and turn *it* into a scary monster.

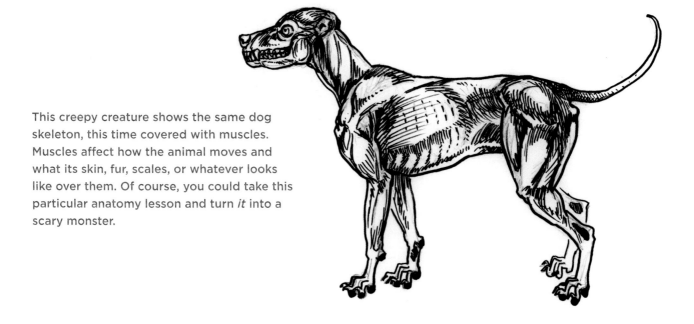

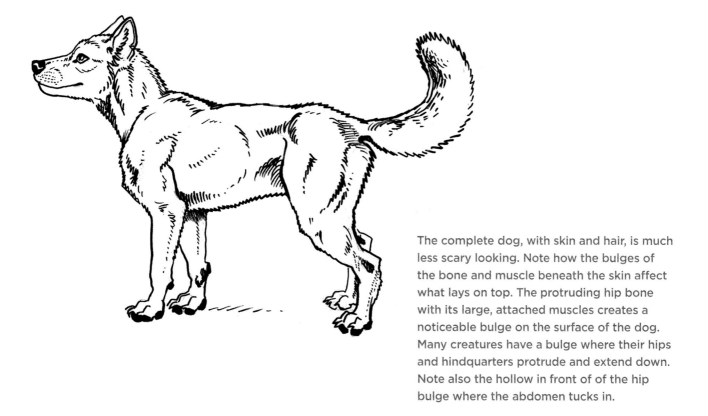

The complete dog, with skin and hair, is much less scary looking. Note how the bulges of the bone and muscle beneath the skin affect what lays on top. The protruding hip bone with its large, attached muscles creates a noticeable bulge on the surface of the dog. Many creatures have a bulge where their hips and hindquarters protrude and extend down. Note also the hollow in front of of the hip bulge where the abdomen tucks in.

Merging two or more creatures into one

Sometimes you want to combine creatures. You like the ears, antlers, or tail of one animal and wonder what they would look like placed on an entirely different species. Any combination of animals you can imagine can be drawn believably as long as you know your anatomy. One key is to seek out the similarities in their different anatomies (like a shoulder blade or a hip bone or the way their neck arches) and use those similarities as lynchpins in the process of combining the two different animals. As long as the selected animal parts blend seamlessly, you can combine any number of species into one character.

The shoulder is one of the basic building blocks you'll need to master. Many animals have shoulder blades, and if you want to combine a land animal with a winged creature, the shoulder blade/scapula is a good starting point in designing the character. The short, stocky puffin seemed a good match to combine with a Scottish Fold cat, which is also a bit on the stout side. Both creatures have shoulders, so I looked at how I might incorporate/combine features from each shoulder into a new animal, as shown in the bottom row. I call my puffin-styled gryphon a puphon. Using the cat's shoulder blade as a base, I added bird wings on top of that in a manner that looked believable to me. Fusing the shoulder blade/scapula of the cat with a smaller, lighter bird scapula on top of it creates a wing and front leg that meld together and are easy for me to visualize and draw in various positions and angles. Note also how the puphon's front leg is now a mix of the front leg of the cat and the leg/foot of the puffin. I made sure my puphon retained the stocky looks of the puffin and cat with short legs and tail.

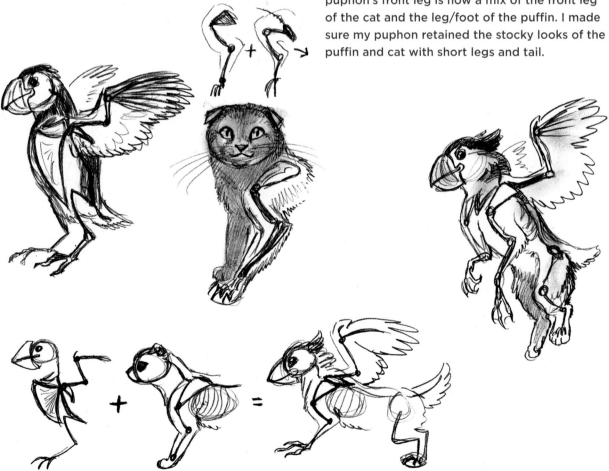

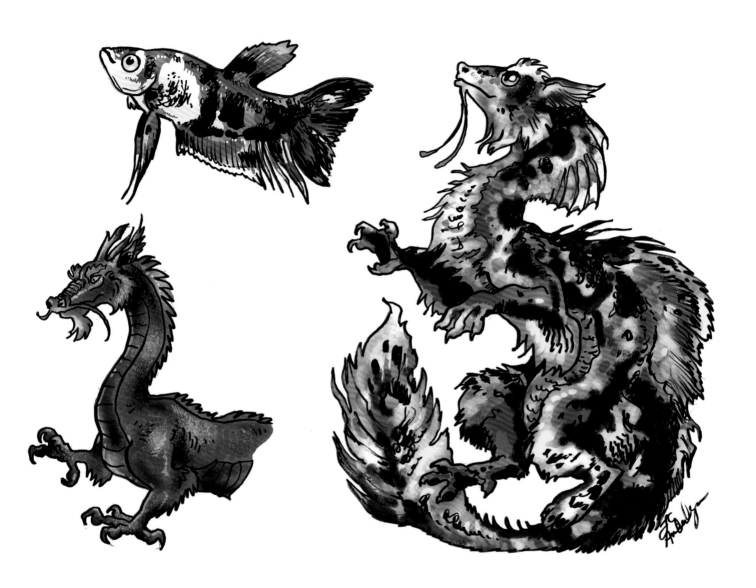

I love to draw dragons. I also love the huge variety of colors, patterns, and long beautiful fins of the betta fish, so I thought, "Why not try combining them?" On left are a koi betta fish and part of an Asian dragon as I would normally draw them. How to combine the two? I first decided the dragon would remain a dragon but with scales and fins more like a fish. On right is the finished blend. Where I normally would draw large scales or feathery fins coming from the dragon's cheek ruffs, legs, and tail, I instead exaggerated those

areas and drew them more like a betta's flowing fins. I shaped the dragon's head as much like a betta as I could without losing the essence of a dragon, giving its snout a shorter, more upturned position like the fish. I colored it in the colors and patterns of a koi betta. In your creature designs, you can use one creature as a base, then add one or more features you like from other animals. Look for elements you like in a species—antlers, a bushy tail, a striking coat pattern—then see how you can combine these disparate features into one creature.

CREATING CHARACTERS: EXAMPLES

In this section, I'll share my thoughts and design processes while showing you how I created various characters.

Nekomata hero

In Japanese folklore, the nekomata is a two-tailed cat demon/spirit or yokai. Many legends speak of how ordinary cats who grow old become nekomatas when their tails split into two. These cat spirits may go to live in the mountains, growing as large as a boar or lion, gaining the ability to walk on two legs and speak, and they often seek revenge for any mistreatment by their former human owners. This got me thinking about a nekomata protagonist for my story.

What if a nekomata experienced human kindness? The legends usually speak of mistreatment but what if a nekomata had experienced love from a human as well? What if this normal cat had endured cruelty but later experienced kindness? How might that affect the nekomata's thinking? Or what if they only knew cruelty as an ordinary cat, but after becoming a malevolent nekomata, they ran into a human who treated them lovingly at a vulnerable time? There are so many ways the story could go. I like to think that the nekomata's mission of revenge might be tempered over time by the realization that not all humans are cruel. This cat spirit might still seek revenge, or perhaps would rescue still-normal cats who are stuck with cruel humans, but now might leave nice people alone, or even help them.

Because nekomatas can walk on two legs, I knew I wanted the female I was sketching to be upright and wearing some sort of human clothing, maybe a simple robe or cloak. She has a diamond-shaped theme, shown in her hood as well as the angular aspect of her face, eyes, and cloak. I kept gravitating toward diamonds, triangles, and other angular forms. I knew I wanted her to have a staff or walking stick but wasn't exactly sure what kind yet.

I continued sketching out ideas, playing with a sweeping, triangular cloak and hood wrapped together by a broad sash. I wanted something simple, like a cat might wear if it did wrap itself in clothing, but distinctive enough to be interesting. I kept trying to "push," or exaggerate, the angular aspect, while softening it a little with the curvy tail and more rounded paws. This nekomata is meant to be a little fearsome but ultimately a good person and I wanted both sharp and soft features to hint at that. I played around with rings, staffs, and seals as decorations but still hadn't quite hit the right note.

Then I thought harder about what a cat might actually wear. What clothing items would a normal cat turned demon spirit have access to and value? Things like collars and toy sticks with feathers on the ends came to mind. What if her staff is actually a cat toy? This could be a good symbol of the kindness she'd experienced from humans at one point. In fact, the toy staff representing human love would be quite symbolic, seeing how she relies on it to help her move forward. The rings around her tails might be cat collars, and perhaps symbols of the suffering and hardship of some of her fellow cats. Maybe they are the collars of her old friends, friends she wants to avenge, or perhaps wants to rescue now! As I add details like these, the character comes more alive, and newer, interesting possibilities suggest themselves.

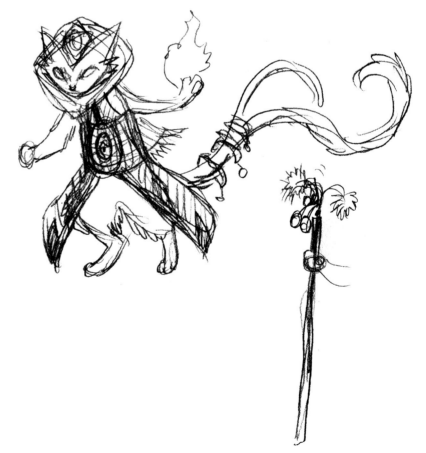

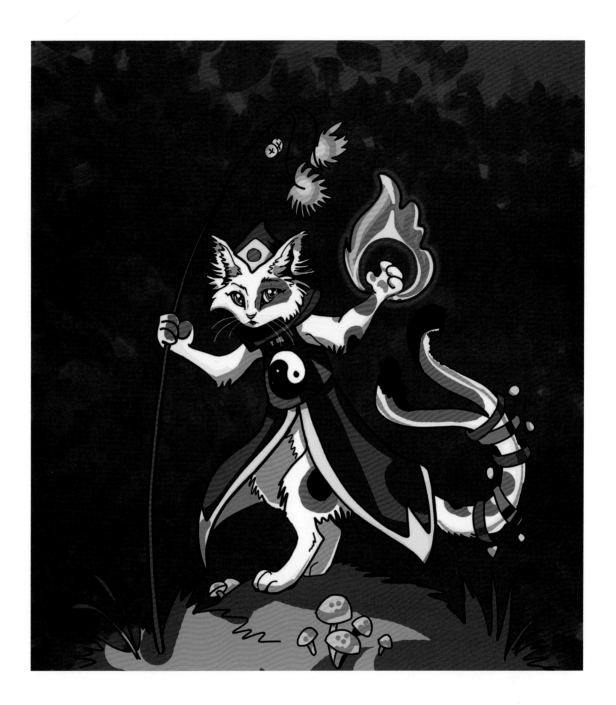

Once I knew exactly how I wanted her to look, I drew and colored my nekomata on the computer using a Wacom tablet and Photoshop. The final version incorporates both the softer and more angular elements of her design, as well as the cat collars and cat toys I'd experimented with in previous sketches. She seemed to me to be a balance between dark and light as a character, so I added a yin and yang symbol to her sash. I chose the primary color red for the cloak to make her stand out, adding the other primary colors of yellow and blue as accents. Next I added secondary colors (orange, green, and purple) to various details and objects, and an eerie bluish glow to the spirit fire she's summoning in her paw. Finally, I added a soft, grayed-out background that helps the brighter colors of the character pop. The green foreground also pops against the red cape, as they are complementary colors.

Space Chicken and Space Weasel

Space Chicken and Space Weasel are characters I created in college for a video game project. Here are some pages from my sketchbook that reveal my thought and creation process as I developed the characters, their design, accessories, and story lines.

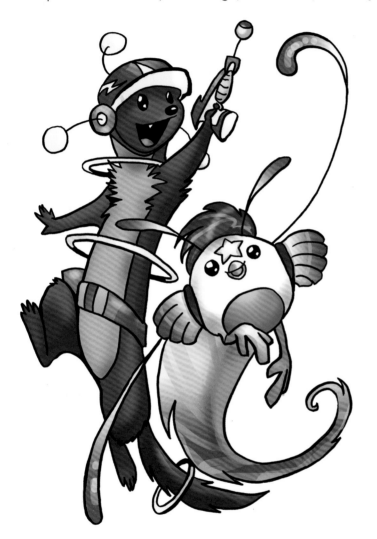

A group of friends and I had an assignment to create the concept for a video game. I was thinking about Easter egg hunts. I used to enjoy them and wanted to create a game where I could hunt for eggs, but with a twist. In this case, the twist was space. I wanted to create a game that was bright, cartoonish, and cheerful and would be fun to watch and play. Anime-inspired characters seemed to fit the bill and I worked on designs that were simple and appealing, much like mascot characters. Everything was space-themed in as zany or silly a way as possible.

In some of my earliest sketches of Space Chicken, I drew him a bit more egg-shaped before deciding the round circle shape worked better and just made him cuter to me. It also took some time to decide how many feelers he would have and what length they would be. I eventually decided on two long ones he can use like arms and two more antennae-like feelers on the top of his head.

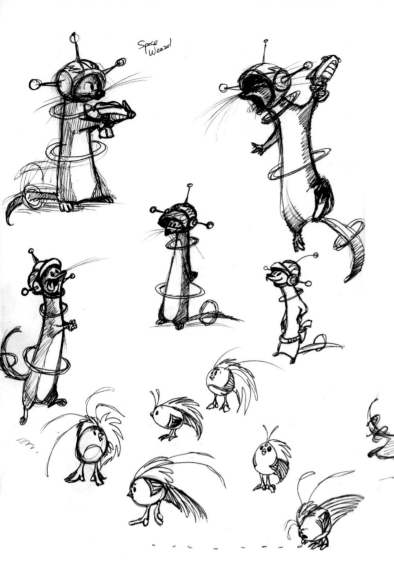

Here are more sketches of Space Chicken and Space Weasel from my drawing pad. Space Weasel gelled inside my head fairly quickly. I knew I wanted a zany, high-energy cartoon weasel, and the space rings all around him seemed silly but right. Sometimes a design just comes to you, which is sure nice. I tried different faces for Space Weasel, going for something overall very pointy before adding more of a separate muzzle from the eyes in the end. Here you can see me playing around with Space Chicken's feelers and tail, too, trying to figure out the right length and number.

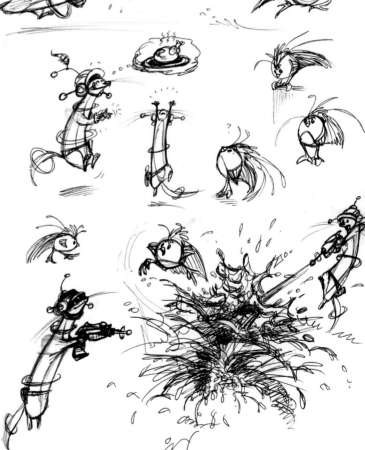

More sketches from my drawing pad. I was just having fun here, working on getting the feel and energy of the characters and seeing how they related to one another. (Space Weasel is very, very hungry, is what he is.)

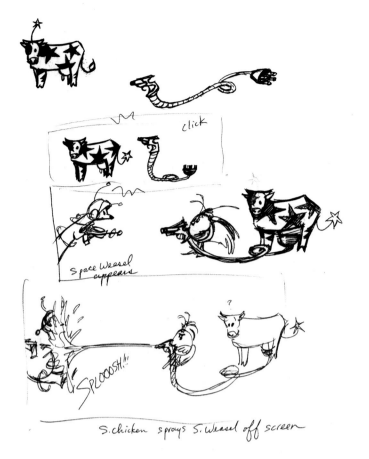

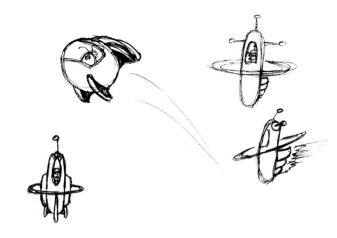

As part of the design concepts, I also brainstormed what Space Chicken and Space Weasel's spaceships might look like. Each takes after their pilot: egg-shaped for Space Chicken and something like a flying hot dog for Space Weasel. Repeating themes, shapes, and colors are useful in making a character design cohesive.

Since this was a design for a video game, I was also thinking about what sort of silly weapons a character like Space Chicken might have in his arsenal. Given how cartoon-like the designs are, a weapon like a gun with bullets didn't seem right. I came up with this idea and drew it: a space-themed cow, complete with udder gun! Space Chicken would be able to hook up to the Star Cow and blast Space Weasel with a flood of milk. Because why not?

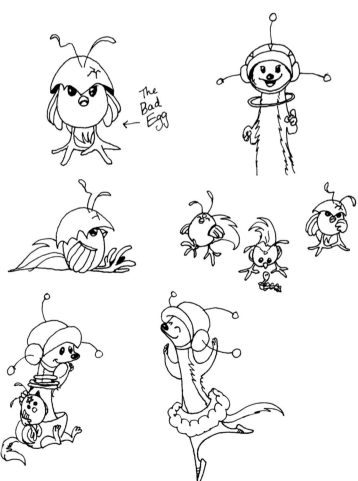

Finally, as part of the Easter egg hunt–style game, I figured some of the eggs might hatch into chicks, and I designed some babies with that in mind. Broken eggshells became hats for some. While I was at it, I decided to design some baby Space Weasels, too, because why not? The whole point was to have fun with my designs. Often, the more fun you have, the more fun your audience will have as well, as your whimsical and creative designs come to life.

Dragons

Dragons! Where to begin? There are so many things you can do with dragons. As long as you have at least a vaguely reptilian feel to your design, almost anything can be a dragon. Anything is possible and almost everything is potentially interesting. You can emphasize or exaggerate certain aspects, whether they be general features or more species-specific things, to create a wide variety of dragon designs.

One thing you can do is take an aspect of some feeling or force that you want in your design and apply it to your dragon. Of course, these things are all true for many creatures, not just dragons, but dragons provide a great example of how to do it. Tweaking small parts of the anatomy here and there can provide different results from similar starts.

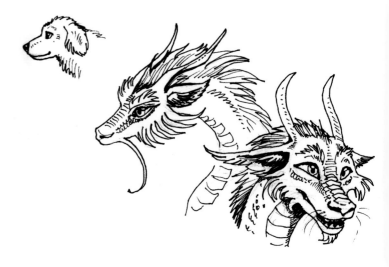

Do you want a dragon that evokes warm feelings in the viewer and a sense of trust? One way to achieve that can be to apply dog-like features to your dragon. Haku from *Spirited Away* is a good example of this. He displays many canine features, especially with his dog-like snout, and it adds to the sense that this dragon is potentially a guardian and protector. Those same sharp teeth that give him some bite against his enemies also make him a little bit frightening. Falkor the luckdragon in the movie *The Never Ending Story* is another example with his extremely dog-like head and ears. Note how I drew this dragon with a dog-like snout, big eyes, and slightly floppy ears, as some dogs have. All add to the friendliness of the creature.

This dragon is designed to be powerful. I took the base of a reptilian creature and made the dragon thick and muscular. The muzzle is short, the teeth are jagged, and the jaw is strong. I added a lot of tough-looking spikes and scales as well.

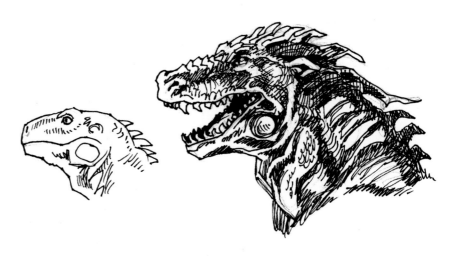

This dragon is more crocodilian in design with a very reptilian look achieved by giving it a croc-like snout and eyes. Using that reptilian base, I then added things like feelers and whiskers that say "dragon," but it retains that crocodilian base, looking a bit exotic and dangerous as a result.

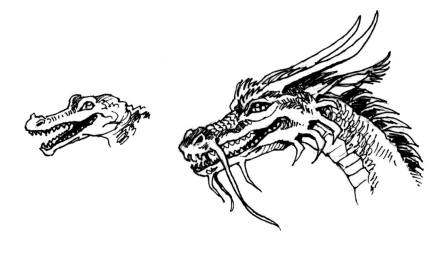

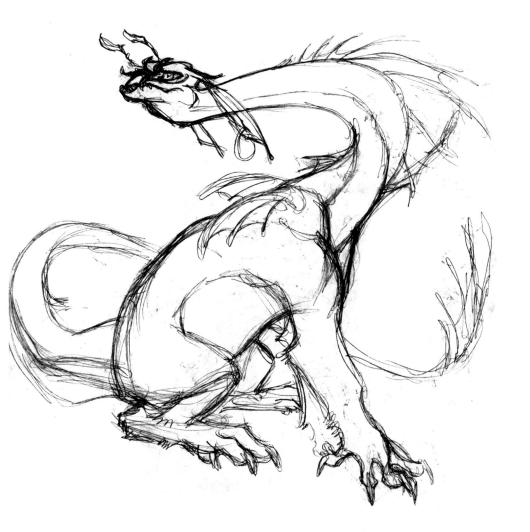

Have fun with your creature designs! Here I simply took a dragon-like concept and pushed parts of it around just to see what would happen. What would it look like if I give it a short muzzle but a long neck, long ears, and almost bird- or cat-like claws? Designed for water (like this one) or designed for flight? The possibilities are endless and the features I, or you, choose will affect its appearance and how the audience reacts to it. But most of all, remember to have fun. Try to draw every "What if?" that occurs to you, and see what happens.

DRAWING REAL ANIMALS MANGA-STYLE

In this chapter we'll look closely at the range of domestic and wild animals commonly found in Japanese manga and how to design and draw them, including 9 step-by-step demonstrations.

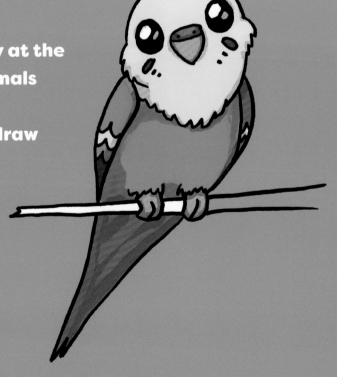

DOGS

Dogs are, not surprisingly, frequently found in manga. Many manga-inspired dog characters reflect Japanese breeds like the shiba inu but can include any dog breed or mixed breed. Whatever your canine character needs, some kind of dog probably fits the bill, whether you want something small, cute, and fluffy for a chibi or companion character or a large, fierce character. The same rules that apply to general character design apply to dogs: rounded forms and soft, droopy eyes look friendly while triangular, pointy ears, teeth, and noses tend to look fiercer.

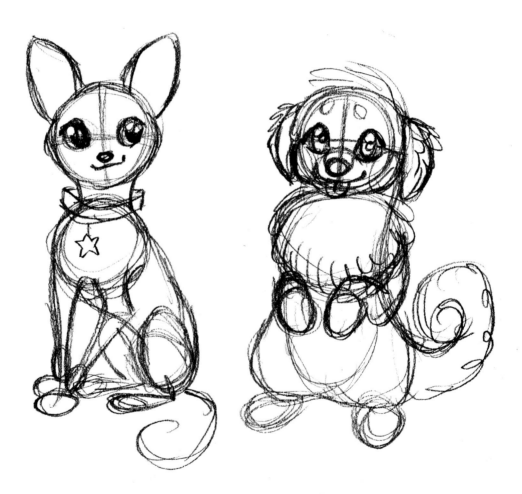

These cute little dogs have rounded heads and bodies, large eyes, and thus overall cute appearances.

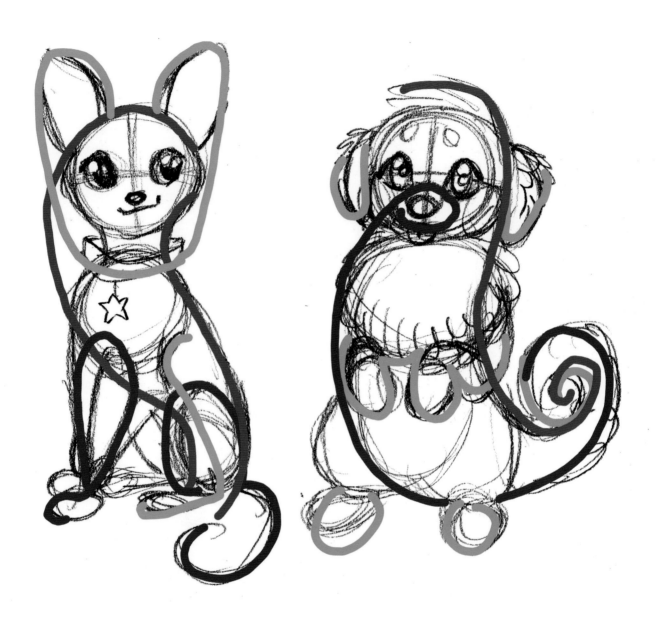

With the color overlays, it's easier to see how I drew many lines flowing into one another. Colored lines indicate strong line flows. This sort of line flow adds to an appealing appearance. Making lines flow into one another and repeating them in the same direction can add to the strength of your drawings.

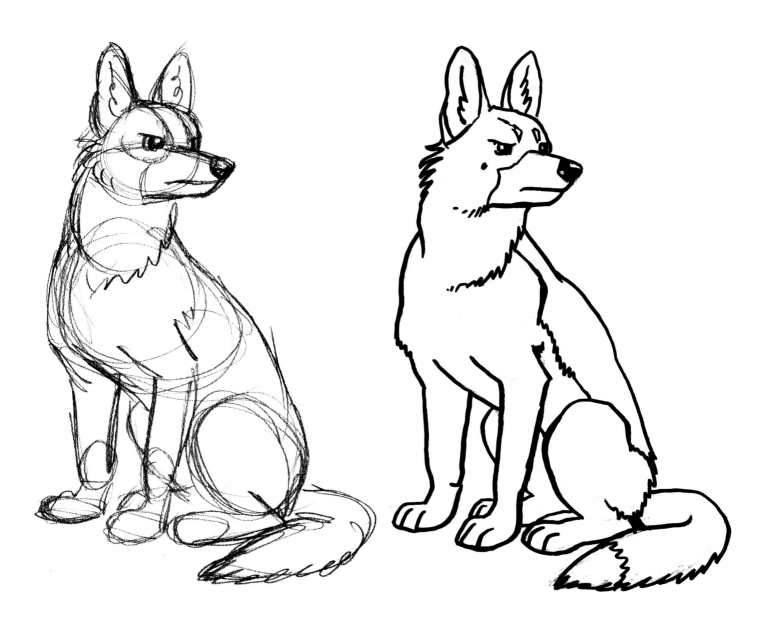

As in these drawings of German Shepherd Dogs, some anime dogs may be drawn more realistically and with smaller eyes. They are usually not main characters when drawn with less expressive eyes but can still be important to the story, nonetheless.

Draw a Shiba Inu dog step by step

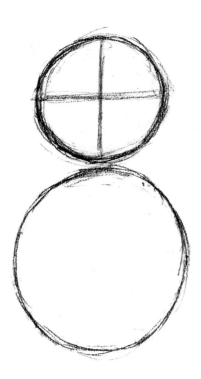

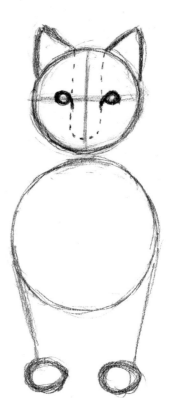

1 Start by drawing two circles, one on top of the other, with the smaller circle on top, as shown. The top circle will be the head and the lower circle will be the chest. Draw two lines dividing the head circle in four equal quadrants to help with proportions later.

2 On the head, add the almond-shaped eyes along the horizontal line, then lightly sketch or dot a U-shape between the two eyes and down to block in where the nose and muzzle will go. Draw triangular ears centered on the two upper quandrants, then continue the sketched or dotted line of the muzzle up from the inner corners of the eyes to the inner corners of the ears. Next, begin drawing the front legs extending down from the outside of the chest circle, ending with ovals for the paws, as shown.

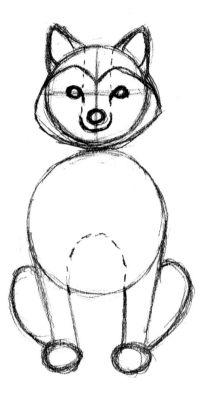

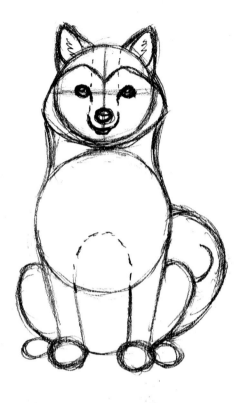

3 Using the guides you made in step 2, draw a U-shaped muzzle near the bottom of the head circle and add a nose just above it, as shown. Define the inside of the ears by drawing almond shapes inside them. Next, draw two arced lines above the eyes, which will separate the white face from the top of the head. Extend that arced line outside the circle and extend it down and out to create the cheek ruffs. The ruff should come to a rounded point about on level with the nose and mouth. To render the legs, draw a subtle upside-down "U" or horseshoe shape extending down from the bottom of the chest circle to the inside of the front leg outlines you drew in step 2. Add curved lines outside the front legs to indicate the sitting hindquarters.

4 Add highlights to the eyes and nose and some squiggly lines inside the ears. Attach the head to the chest by drawing a neck, then add oval-shaped hind feet and a bushy tail on one side that curls over.

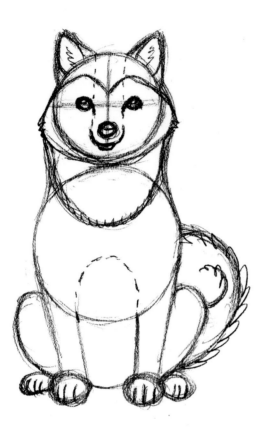

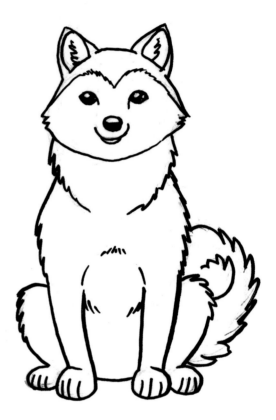

5 Draw a wide "U" or horseshoe shape under the dog's head to indicate his front neck. Add toes to all feet, and fluff out the tail and cheek ruffs as desired.

6 Draw the final lines in ink or digitally, adding shaggy, zigzag strokes along the outer edges to indicate fur, and then erase any pencil or guidelines as needed.

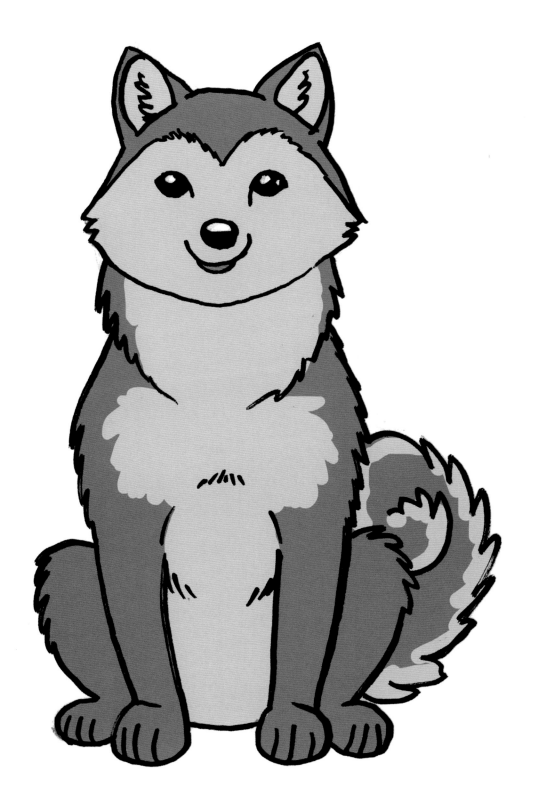

The shiba inu in color.

CATS

Cats, like dogs, are a staple of manga and Japanese folklore. They can be cute, friendly familiars or terrifying demons and everything in between. Like dogs, the way you design them can range from round and reassuring to sharp and edgy. Cats appear both as our furry feline friends and as various yokai, or Japanese spirits or demons. (I delve into the yokai in chapter 5, page 140). The Maneki-neko, the lucky cat statue that beckons customers in with a wave of its paw is a familiar sight in Japanese stores.

You can play around with changing proportions on a face to create different-looking characters, even of the same species.

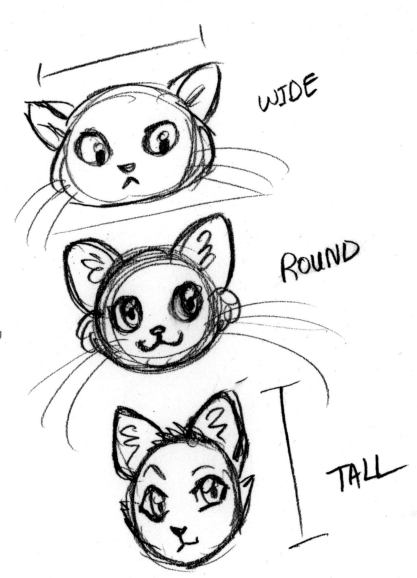

Cat-girls are a staple of manga as well as comics in general. They can be either more human or more feline but generally carry elements of both. Note how many of these cat-girls have one sharp tooth sticking down from their upper lip/muzzle. This is a common manga style, often indicating a sharp or edgy element in an otherwise cute and soft-seeming personality.

How to draw a Maneki-neko (beckoning cat) step by step

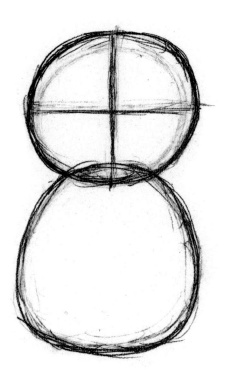

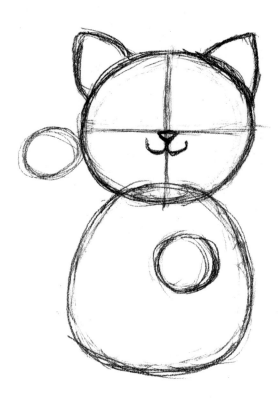

1 Draw the head as a circular shape, almost an oval that is slightly wider than tall. Divide it into four equal portions by drawing horizontal and vertical lines as shown. Below the head, draw the body. It should be slightly gumdrop-shaped, wider at the bottom than at the top, and overlap into the head circle just a bit.

2 Draw the cat's nose in the center of the head as an upside-down triangle. Just below the nose, draw the mouth as a curved line that goes down, then up, then down then up. Draw triangular ears above the circle, and sketch two circles for the front paws, one on one side of the chest and the other that will be beckoning, up near the cat's cheek.

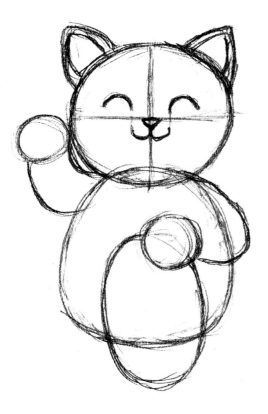

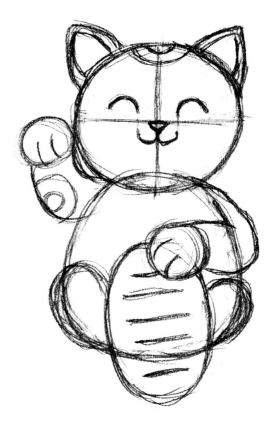

3 Draw arced lines for the top of the cat's eyes. Note how I started the inside corners of those eyes directly above the corners of the cat's mouth. Add triangular insides to the ears. Draw the lifted arm and the outside edge of the lowered arm. Draw an oval shape being held by the lower paw, which will dip down below the body just a little bit. This will become a big coin.

4 Draw toes on the cat's front paws and finish drawing the the lowered arm you started in step 3. Draw oval shapes on the bottom of the body to indicate the hind legs. Start drawing the spots of color on the cat's elbow and on the top of its head. Draw several straight lines in a row that go from side to side on the coin.

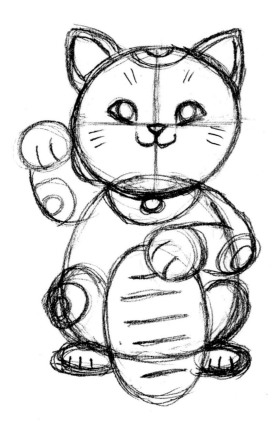

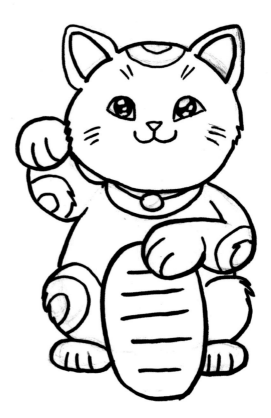

5 Draw a collar, bib, and metal tag hanging under the cat's neck. Finish adding spots on its elbows and on one or both knees, and add the whiskers to its cheeks and above its eyes. If you'd like, you can open its eyes by drawing slanted lines from the outside corners down to the inside corners and add pupils as shown.

6 Draw the final lines in ink or digitally, and erase any pencil or guidelines as needed. Add several highlights to the eyes if you drew it with its eyes open.

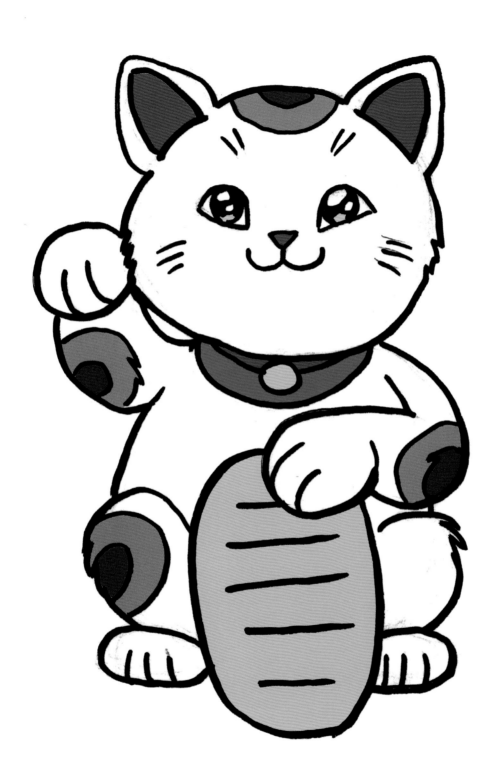

The Maneki-neko in color.

RABBITS AND RODENTS

Rabbits and rodents are two different types of animal (a rabbit is a lagomorph), but they are both small, fuzzy, and often drawn in similar manners, especially when depicted in a cute style.

Rodents

Common rodents found in manga include mice and rats, hamsters, and squirrels. All feature rounded, small bodies, and all are often found around homes or as pets.

Many rodents can be drawn in quite similar ways, especially in a more cartoony or manga style. They frequently feature big heads, big eyes, fuzzy chests, and rounded bodies. These four stacks of ovals provide the same foundation for four very different rodents (opposite, top).

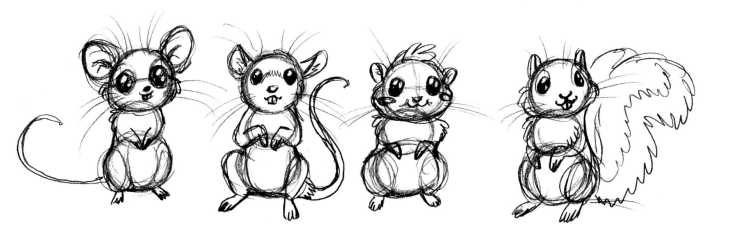

Starting with the stacked ovals shown opposite, I created four distinct characters by using different combinations of features, such as the proportion of the eyes and ears to the rest of the body, the size and shape of the ears, the length and fullness of the tail, the number of whiskers, and the amount and softness of the fur. From left to right are mouse, rat, hamster, and squirrel.

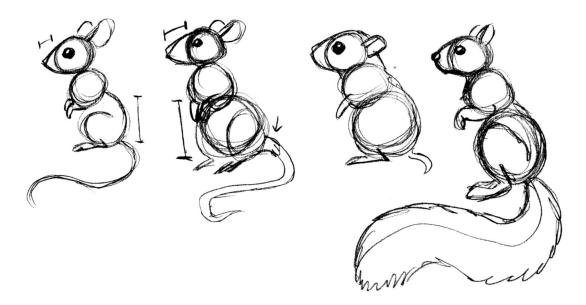

All of these rodents were drawn from the same three-circle base. Note that while they are all somewhat similar, the more realistic the drawing, the more noticeable their differences, and the more you should highlight each animal's unique features. For instance, the mouse's muzzle (left) is not as large in comparison to the rest of its head as the rat's (second from left) is. The rat has proportionally smaller ears and head and its limbs are thicker. In addition, the rat has a more pronounced base to its tail, where there is some fur at the base before it turns hairless and scaled. The hamster (second from right) is proportionally more mouse-like but with a short tail and small ears. Mice and hamsters have proportionally large eyes, squirrels and rats less so (but still rather large). The squirrel is more rat-like but with a (usually) bushier tail. Its limbs are strong and developed. There are of course exceptions to these rules. For instance, some mice have hairless tails and some don't. Some squirrels have bushy tails and some do not.

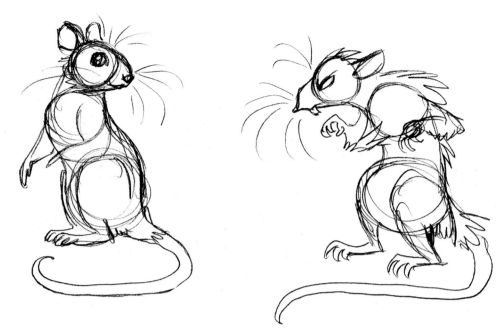

A soft, cute mouse will be drawn much rounder and softer than a sewer rat meant to be an antagonist. But what if your rat character is a protagonist? Odds are you'll design it with a friendlier look. Note how the rat on the left has rounded features that soften its long muzzle and give it an appealing look. The rat on the right is designed as a villain, with sharper and far more triangular features. Its pupils have been left entirely out, giving it an eerie, menacing presence.

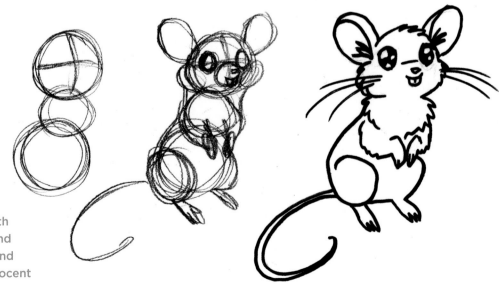

Mice are smaller, usually with less pronounced muzzles and proportionally larger ears and eyes, making them look innocent and cute.

This beloved pet is the epitome of round and cute. Everything about a hamster is soft and fuzzy. Note how the body is drawn in a chibi style (see page 72) with huge eyes, big head, tiny body, and short limbs.

Tree and ground squirrels are common backyard wildlife across many places in the world. Tree squirrels usually (but not always) have bushier tails than ground squirrels. This squirrel's round shapes, huge eyes, and overall fluffiness reinforce its appeal.

Rabbits

Rabbits are often drawn in a similar manner to rodents: cute, round, and furry. In general, their soft, sometimes circular forms are emphasized to bring about a cuddly, gentle appearance. Of course, if the rabbits of your story are villainous, they might be depicted with sharper features, much like the evil rat type shown earlier (page 106).

Note how rounded and circular the forms of these rabbits are. Here I've sketched them in with a pencil.

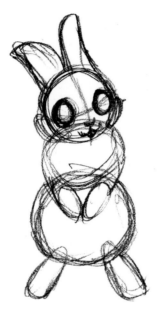

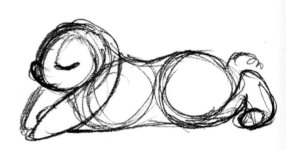

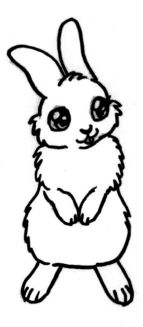

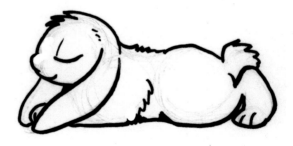

The finished forms, finalized with ink. The rabbit on the right is a lop-eared bunny, recognizable by its droopy ears.

How to draw a rabbit step by step

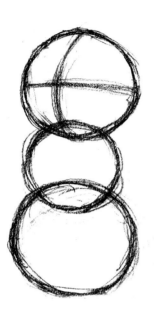

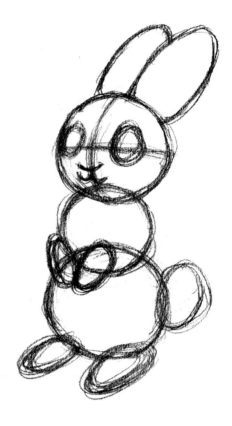

1 Start by drawing a snowman-like shape. One circle for the head, one slightly smaller circle below it for the chest, and one the same size as the head below the chest for the hindquarters. Make sure they overlap somewhat. Add some feature placement guidelines as shown to the head, slanting the horizontal line slightly up in the center and drawing the vertical line in a curve toward the left, a bit left of center. The rabbit will be facing slightly toward the left, and the vertical line will be the center of its face.

2 Add features to the rabbit, including the eyes, nose, and mouth on the face, using the curved vertical line to inform you where the center of the face is and thus the center of the nose and mouth. The eyes go on either side, with some space (about an eye width) between them. Draw the ears on top of the head, placing them back on the head a bit as shown. Draw ovals for the front feet and draw the hind feet as long ovals too. Add a tail.

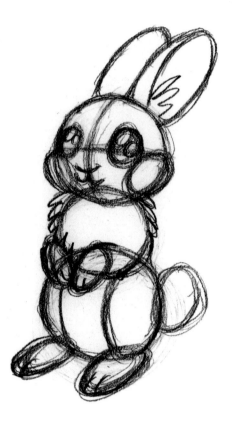

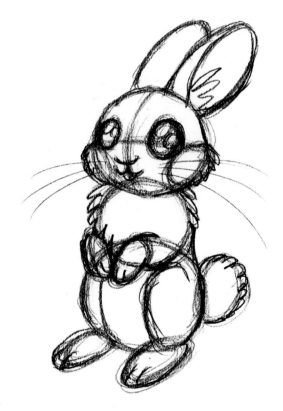

3 Add highlights to the eyes and two ovals on each side of the face to give the bunny puffy cheeks. Add detail to the ears and some fluff to the rabbit's chest, widening it somewhat. Draw toes on all the feet. Indicate the legs and belly of the bunny with two curved vertical lines running along either side of the tummy. This will create an oval where depicting the near hind leg.

4 Draw buck teeth under the peak of the mouth and use squiggly zigzag lines to indicate fuzzy cheeks. Add whiskers. Define the front legs. As it happens, you can use the curves of the bottom of the chest circle and the top of the hindquarters circle to help guide you draw the front leg. Define the hindquarters a bit more and add fluffiness to the tail.

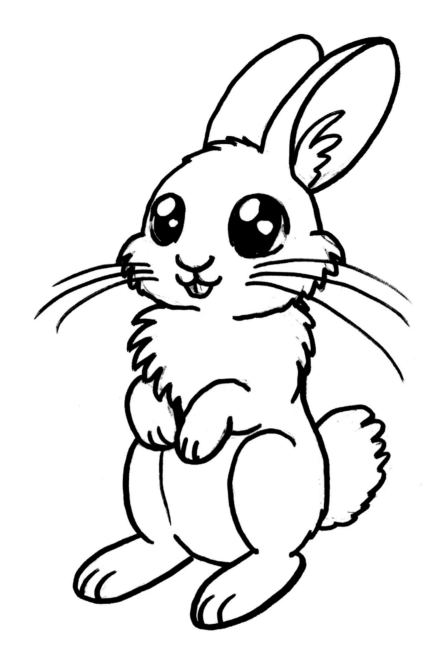

5 Finish the drawing, adding the final inked lines and erasing guidelines as needed.

HORSES

Horses are fairly common in manga, serving as beautiful, graceful steeds to carry our heroes (or villains) into battle. Drawing a manga-style horse gives one the opportunity to elaborate the flowing mane and graceful curves found in these beautiful animals.

How to draw a horse step by step

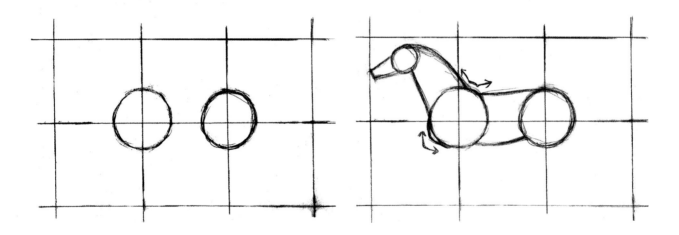

1 Begin by drawing a rectangle, and then divide it into six equal parts, making a grid. Draw two circles in the two center cross sections of the grid. These will be the chest and hips.

2 Draw the horse's head circle in the top center of the upper left of the grid. Draw the neck up to the head from the chest circle, starting at the top and a little behind the circle's center, curving it steeply over to attach smoothly to the back of the head circle. Add a rectangular muzzle on the other side of the head circle, narrowing the end slightly. Add some bulk in the front of the chest circle (see arrows) to emphasize the muscular shoulders. Draw the back and belly as shown.

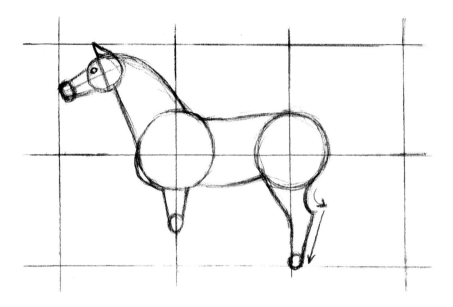

3 Use two perpendicular lines to divide the head into four equal quadrants, angling the vertical line slightly forward since the head is gently tilted forward. Draw an oval that just barely extends out from the tip of the muzzle to indicate where the horse's nostrils and mouth will be. Place an angular shape for the ears on top of the head, using the dividing lines you just drew for placement. Start the front of the ear at center and sweep the back line of the ear into the back of the head. Add an eye on the top left part of the head circle. Draw the tapering top of the front leg with a circle on the bottom for its joint. Begin the hind leg, using the grid to help you line up the front of the lower hind leg. Add a circle at the bottom for the joint there.

4 Add the horse's mane and tail. You can have fun here making the mane as wavy and luxurious or short and clean as you want. Make it your own. Manga-style drawings often emphasize the intricate beauty of nature with attention to detail and you can certainly do that with the horse's flowing hair. Once you're done, scoop the line in on the front base of the ear to narrow it a bit and add the nostrils and mouth. Below the joint of the front legs, add the rest of the leg, centered through the grid line, and then add a circle for the next joint below. From there, draw a hoof, letting the front stick out sharply and then making it more rectangular behind. Do the same with the hind leg.

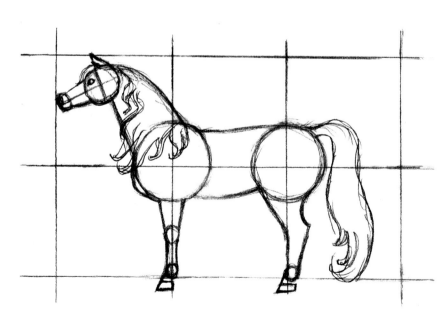

5 Add the final details, such as a highlight in the eye, the drape and curl of the mane, the flair of the tail, bangs, and the indentation created by the hollow area in the horse's hock, or ankle, as shown. Connect the hooves to the rest of the legs. Make sure to add the farther ear and legs as well. Make sure the lower legs are both about the same thickness, thinning or thickening them if desired.

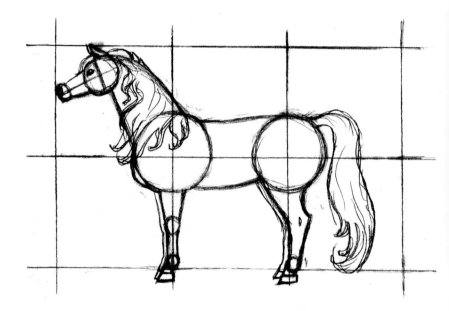

6 Finish the drawing, inking in the lines and erasing guidelines as needed.

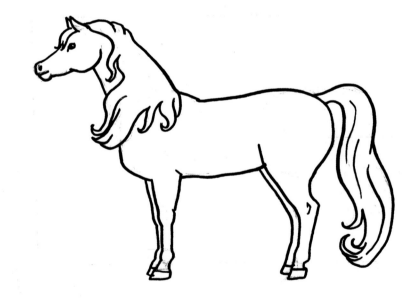

PIGS

Pigs are intelligent animals that can be quite adorable as babies. Their snouts are distinctive, making them easy to recognize, whether drawn realistically or very cartoon-like.

How to draw a pig step by step

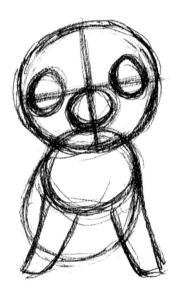

1 This chibi-style pig will feature a comparatively large head and big eyes. Start by drawing a head circle, then add a smaller chest circle and small oval below that for the body as shown.

2 On the head, add the nose (a circle just below the center of the head) and two large wide-set eyes on either side of the nose, a bit above center on the horizontal line. I drew the eyes here slightly egg-shaped. Add the front legs, tapered and rectangular, sweeping them down from the chest circle to rest on the ground.

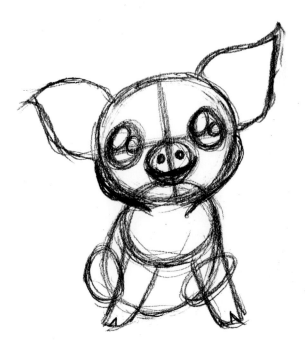

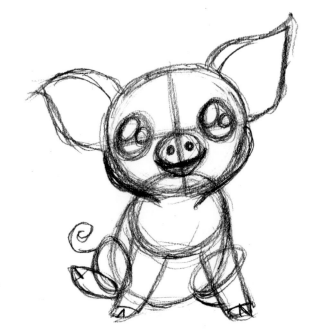

3 Add highlights to the eyes and nostrils to the nose. Define the mouth on the bottom part of the nose circle and add a small line for the chin as shown. Draw the ears, making them somewhat teardrop-shaped and floppy-tipped. Add a small amount of bulk to the cheeks, and curve the lines down to indicate the neck. Draw inverted triangular shapes to create hooves and add small ovals behind the front legs to show where the hind legs will be.

4 Finish building the pig's form. Add lines inside the top of the ears to define them. Draw horizontal lines to separate the front hooves from the legs, and draw the hind feet, especially the one visible on the left, giving it a pointy tip. To render the hooves on the tip, draw the base of the hooves and a perpendicular line in the middle to create two hooves there. Add a curly tail.

5 Finish the drawing, inking in the lines and erasing guidelines as needed.

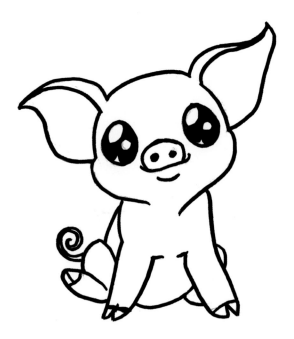

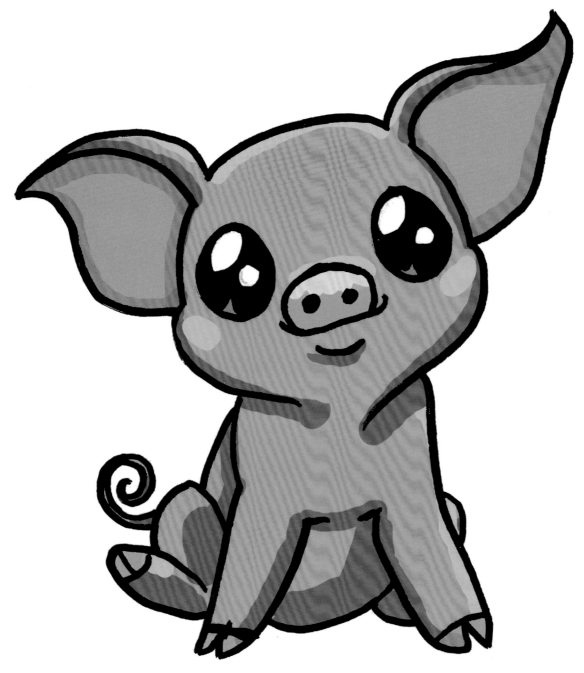

The pig in color.

BIRDS

There is an almost infinite variety of colors, shapes, and sizes in the bird world.

How to draw a bird (parakeet) step by step

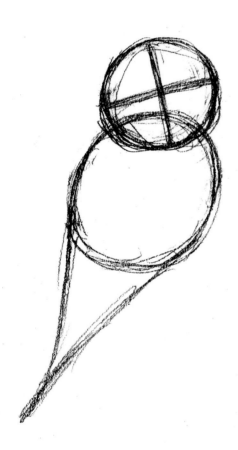

1 Draw a circle for the head and a slightly larger overlapping oval below it for the body. The bird's tail points down and slightly to the left, so angle the body oval in the same direction as the tail. Draw the tapering tail, which with the body makes a teardrop shape. Add guidelines to the head that divide it into four equal quarters. Tilt the vertical line over to the left and the horizontal line down to the right because the parakeet's head will be cocked to that left side.

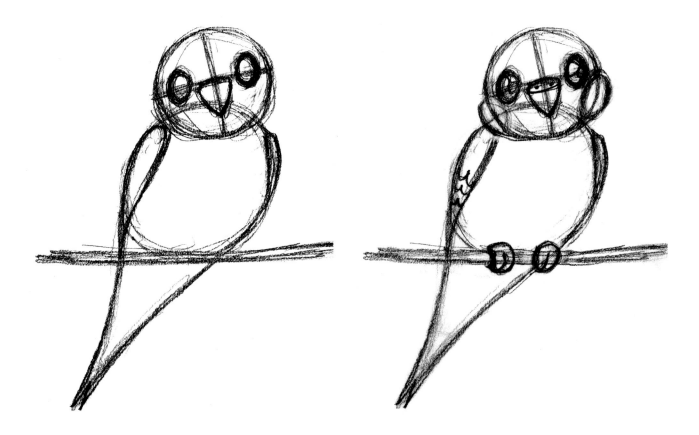

2 Draw the beak and the wide-set eyes, making sure to leave a little space between the beak and each of the eyes. The top of the beak should be on the horizontal line and shaped a bit like a candy corn (slightly rounded upside-down triangle shape). Add the wings on either side of the body as shown, shaping them like narrow teardrops that bend with the curve of the body itself. Add a few hints of feathers at the tip of the tail and draw a branch under the body.

3 Add highlights to the eyes and the cere (the bare, soft base of the beak where the nostrils are located). Add the nostrils, too. Draw ovals to create puffy cheeks, and add some details on the wings to indicate feathers and markings. Add feet, making a curved shape on the viewer's left side and slightly more rounded foot on the right, since the parakeet is standing with its toes pointed slightly inwards.

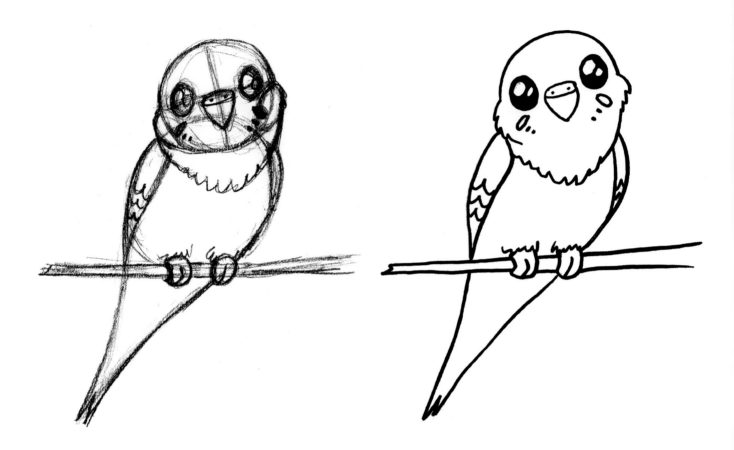

4 Define the parakeet's neck, drawing a line down from the puffy cheeks to the middle of the chest, and then continue this line and sweep it up to connect to the other side of the neck. This indicates the separation of the lighter face and neck from the body, and renders the neck feathers over the chest, as shown. Add markings below the eyes and some poofy feathers above the feet to indicate the legs underneath.

5 Finish the drawing, adding inked lines and erasing pencil or guidelines as needed.

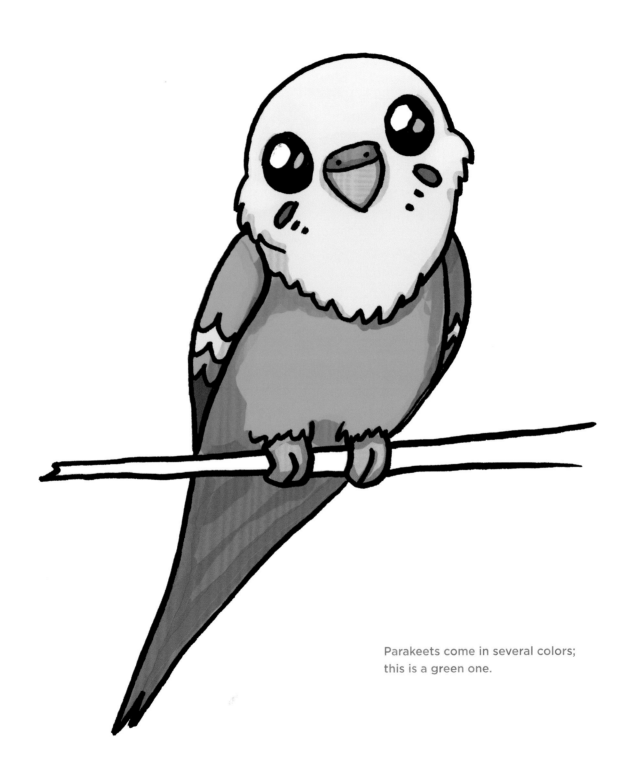

Parakeets come in several colors; this is a green one.

FOXES, WOLVES, AND TANUKIS

Foxes and wolves are wild dog species that have long played a key part in storytelling worldwide.

The tanuki is a raccoon-like member of the dog family native to Japan and some other East Asian countries that has long played a key part in Eastern storytelling.

Unfortunately, wolves have often been cast as villains in our stories, since they travel in packs and can prey on livestock, but the actual animal is an interesting, intelligent, and social canine with many of the characteristics we admire in our domesticated dogs, their relatives.

Foxes, too, have often been cast as villains or tricksters but seem to be coming into their own nowadays as more people realize what beautiful, charismatic animals they are. Wolves, foxes, tanukis, and other wild dog species can provide an interesting part of any manga-style story you wish to design.

Foxes

The red fox is the best-known fox species and the one found in Japan. Its gorgeous orangish coat with dark brown/black accents and white throat and tail tip make it extremely recognizable.

The fox's face is characterized by pointy ears, a long nose, and slightly slanted eyes. Like most animals mentioned in this book, the way you approach drawing the fox's face can go a long way toward communicating if it's a hero, villain, or something in between. You can draw it sharp and sly, emphasizing triangular features to portray a crafty, cunning thief (bottom left), or use more rounded, soft shapes in its features and body to make it seem friendlier (bottom right).

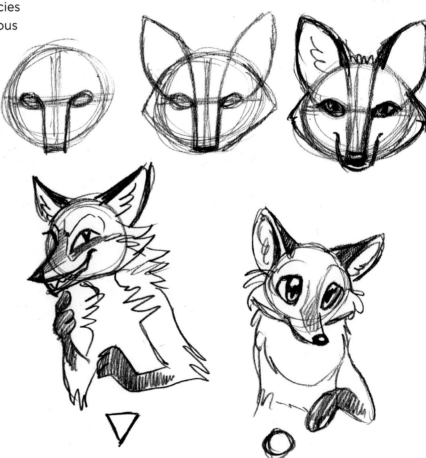

Wolves

Wolves look much like a husky or malamute or other large dog breeds. But, in general, their muzzles are often thicker and/or longer, their paws are larger, and their chests are narrower. In Japan, there were once two wolf subspecies, now both extinct: the Japanese wolf, which was on the small side and associated with the mountains, and the Hokkaido wolf, a larger wolf that was more closely related to the wolves of North America. Wolves were also associated with yōkai called okuri-ōkami (sending off wolf) or okuri-inu (sending off

dog), which would escort travelers making their way on trails through wild mountain passes at night. Stories vary, but these creatures could be friend or foe. If a traveler tripped, they might be torn to pieces, or they could pretend to have tripped on purpose and the wolves would leave them alone. Being naturally fierce, these okuri-ōkami scared off any other wild animals and could ultimately help travelers reach their destination safely. At which point it was wise to thank them with a gift for their help and then be on one's way.

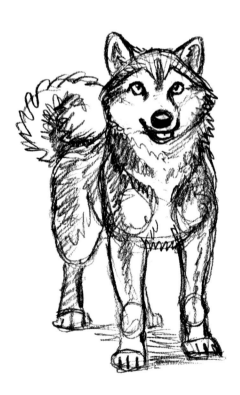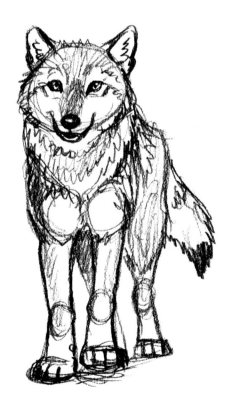

Here's a side-by-side comparison of a dog (left) and a wolf (right). Note how the wolf is larger than the dog, with longer legs and a darker face. The wolf's paws are larger and its chest narrower.

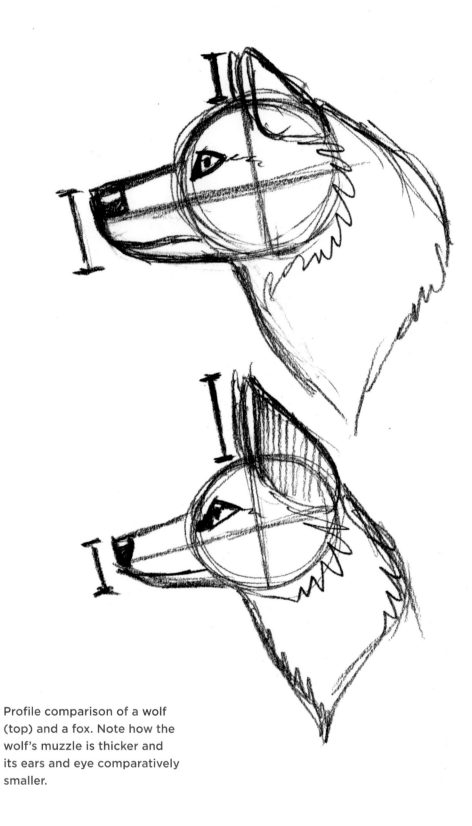

Profile comparison of a wolf (top) and a fox. Note how the wolf's muzzle is thicker and its ears and eye comparatively smaller.

How to draw a fox step by step

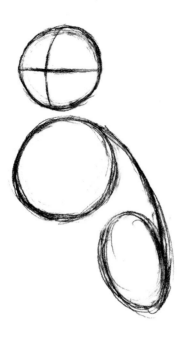

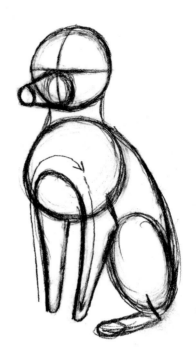

1 Please note that this fox will be sitting and facing in a three-quarter view to your left. Draw a circle for the head, drawing slightly curved vertical and horizontal guidelines that divide the head into four unequal sections. Since the fox will be looking off to the left, the vertical line is placed to the left of center and curving out to the left. Draw a larger circle underneath the head for the chest, then extend a line from the back of the chest to loop around where the hips will be, as shown.

2 Add a cone-like muzzle in the center bottom of the face, making it slender and narrower at the tip. Draw the front legs by basically sketching a slightly bent horseshoe shape that arcs up from the same level as the bottom of the hip circle and loops up and over the front of the chest before extending down to the bottom again (see arrows). Continue this line, keeping the end (wrist) rounded (the paws will come next, so leave some room below this). Continue the line up toward the back, and give the fox an elbow before angling the leg line to meet the rib cage part of the chest circle. Finally, add the hind leg, as shown.

3 At the top and sides of the muzzle cone, add the eyes along the horizontal guideline. Make them somewhat almond-shaped and slanted, and make each outer corner line up with the horizontal line, as well. Extend a sloping horizontal guideline from the inside corner of the closest eye, down the muzzle, to the tip of the muzzle cone, creating the nose. Draw cheek ruffs on the outside of the head that start along the horizontal line on either side, poof out, then sweep back in. Draw front paws under the front legs. Draw a curved line behind the far front leg to indicate the front half of the far hind leg. Add the luxurious, fluffy tail.

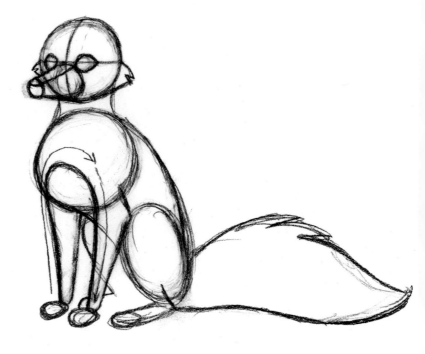

4 Draw dotted guidelines, parallel to the center guideline, from the inside corner of each eye to the top of the head. From there, start to draw the ears from the inside corners, making them large and triangular and extending down to the cheeks. Draw the irises and highlights in the eyes. Draw a mouth, and make the nose a little larger on the bottom. Draw fur on the chest and add toes to its far feet. Finish the hind leg, adding a foot and the back of the leg. Add a white tip to the tail.

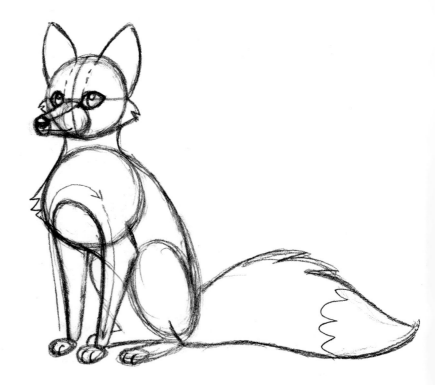

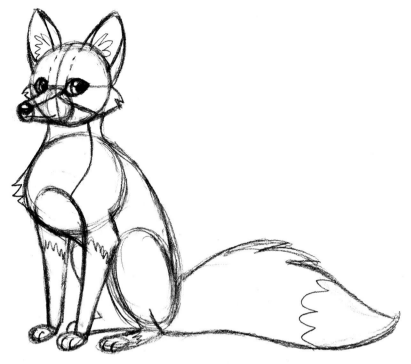

5 Finalize the fox, adding the insides of the ears and tufts of hair. Draw the pupils, and add markings like the white patch of the muzzle, extending to the throat and down the chest, as well as dark patches on the legs. Add the belly.

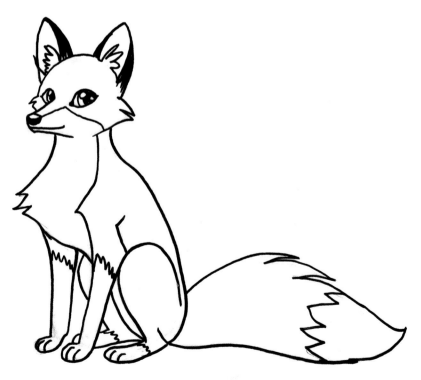

6 Finish the drawing, inking in final lines and erasing as needed.

Tanukis

The tanuki is a raccoon-like member of the dog family native to Japan and some other East Asian countries. The tanuki, or raccoon dog, is fairly common and adaptable and found in a range of environments, from forest to urban areas. Tanukis have a long history in Japanese folklore as shape-shifters and tricksters, sometimes appearing comical, lazy, and gluttonous, and other times more sinister. A cartoon tanuki with a drinking jug and wide-brimmed hat is a common theme.

How to draw a tanuki step by step

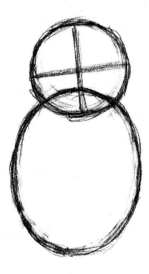

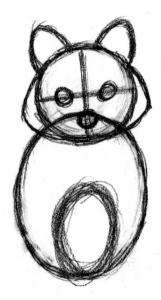

1 Draw a circle for the head and add a vertical and a horizontal guideline, dividing the head equally into four parts. Tilt the head slightly to your left, as shown. Then draw an overlapping oval at the bottom of the head, long ends pointing up and down. This oval will become the front legs and chest.

2 Add cheek ruffs to each side of the face and medium-sized, pointed ears. Draw the eyes and nose. Add a smaller oval in the bottom center of the chest oval to begin defining the legs.

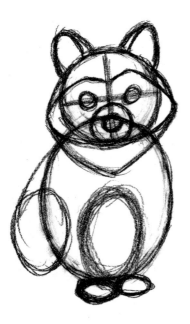
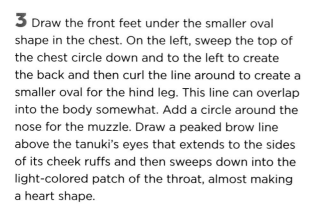
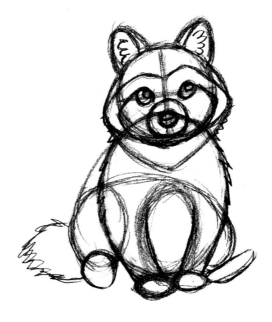

3 Draw the front feet under the smaller oval shape in the chest. On the left, sweep the top of the chest circle down and to the left to create the back and then curl the line around to create a smaller oval for the hind leg. This line can overlap into the body somewhat. Add a circle around the nose for the muzzle. Draw a peaked brow line above the tanuki's eyes that extends to the sides of its cheek ruffs and then sweeps down into the light-colored patch of the throat, almost making a heart shape.

4 Define the eyes and add highlights to them. Refine the nose, and add tufts of hair inside the ears. Draw the raccoon-like facial mask, using the muzzle circle to help guide you and keeping the bottom line of the mask a little below the chin. Add some shaggy fur to the legs as you define them as well, adding some thickness to the wrists where they meet the paws. Draw the hind foot and then, using the curve of the hind leg to guide you, sweep around in an arc to the other side of the body where the other hind leg is. Draw that foot as well. Add the short, bushy tail.

5 Finish the tanuki, making sure everything is as you want, adding fur along the neck, legs, or wherever seems to need it and placing markings on the front legs. Add the toes and a paw pad on the hind feet.

6 Finish the drawing, inking in the final lines and erasing where needed.

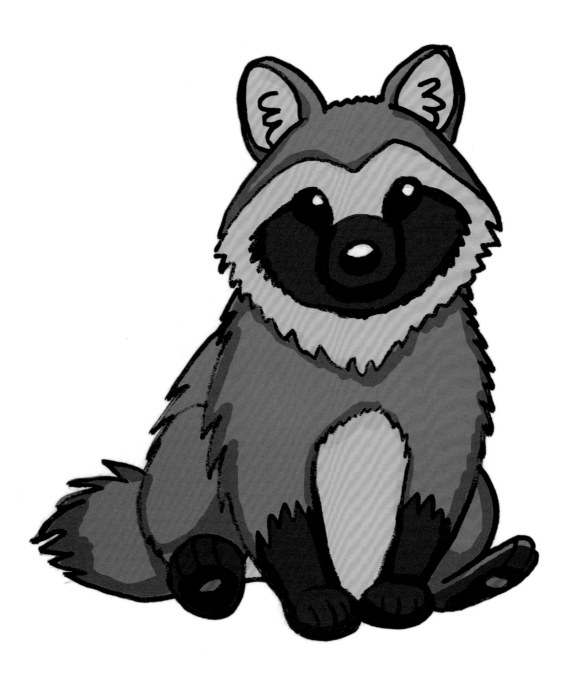

The tanuki in color.

DEER

The sika deer is native to Japan and other East Asian countries and has been introduced into several other countries around the world. In the Japanese Shinto religion, these deer were long seen as messengers for the gods, and were/are considered to be a sacred and lucky animal. They are one of the few deer that keep their spots as fawns into adulthood.

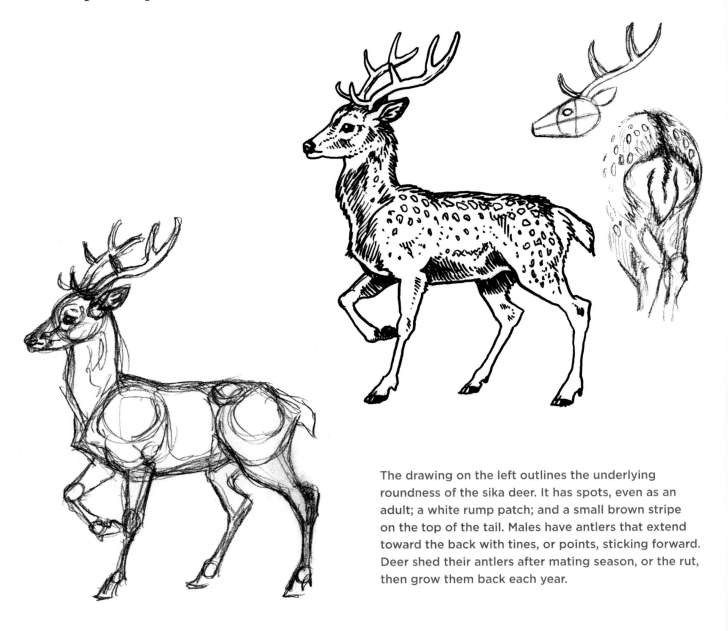

The drawing on the left outlines the underlying roundness of the sika deer. It has spots, even as an adult; a white rump patch; and a small brown stripe on the top of the tail. Males have antlers that extend toward the back with tines, or points, sticking forward. Deer shed their antlers after mating season, or the rut, then grow them back each year.

SEROWS

Japanese serows are a type of goat/antelope found in forested and mountainous areas of Japan. They live alone or in small family groups. The sure-footed and swift serows are a national symbol in Japan and as such they are afforded special conservation status to ensure that they will always be a part of the wild lands there.

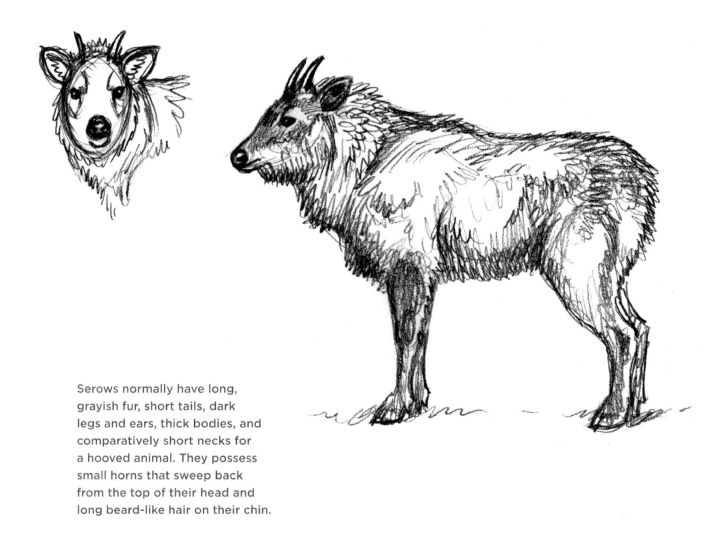

Serows normally have long, grayish fur, short tails, dark legs and ears, thick bodies, and comparatively short necks for a hooved animal. They possess small horns that sweep back from the top of their head and long beard-like hair on their chin.

BEARS

Japan is home to the Japanese black bear, a subspecies of Asian black bear, and the larger Ussuri or Ezo brown bear. The bear is a formidable figure, both in folklore and reality, though in the wild its numbers are declining. In folklore, there were legends of bears that lived so long they became onikuma, monstrously strong yōkai or demon bear that lived in the mountains and would come down at night to steal horses and cows, carrying them back to their lair to eat. They could also hurl huge rocks one human alone could never hope to throw by themselves.

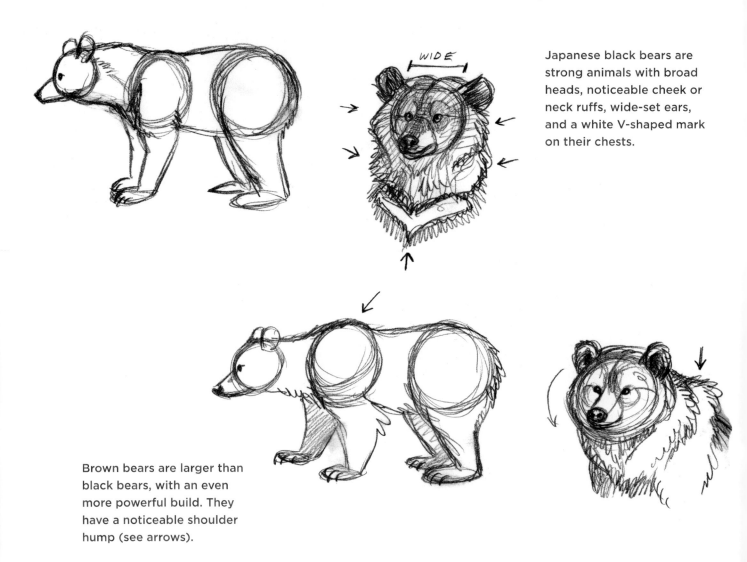

Japanese black bears are strong animals with broad heads, noticeable cheek or neck ruffs, wide-set ears, and a white V-shaped mark on their chests.

Brown bears are larger than black bears, with an even more powerful build. They have a noticeable shoulder hump (see arrows).

MONKEYS

Monkeys feature prominently in Japanese mythology and folklore. The species found in Japan is the Japanese macaque, or snow monkey. They are well known for their penchant for taking long baths in hot springs during the snowy winter. There are many references to monkeys in Japanese language and stories, ranging from positives like being mediators between humans and gods, to negatives such as embodying human traits that deserve to be ridiculed. The three wise monkeys associated with "See no evil, hear no evil, speak no evil" came from a carving on a shrine in Nikkō, Japan. The Chinese novel *Journey to the West*, starring the Monkey King, was the inspiration for Akira Toriyama's incredibly successful *Dragonball* manga series.

The Japanese macaque is a beige or gray-brown monkey with a short tail and a reddish face. They bathe together in hot springs, sometimes grooming one another.

How to draw a monkey step by step

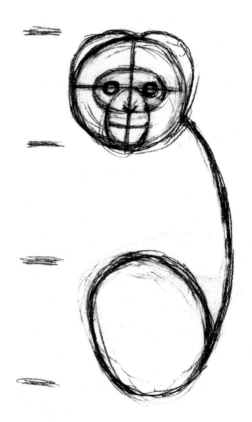

1 Draw a circle for the monkey's head higher up on your drawing surface, leaving a large space below it for the full body to be added later. Draw horizontal and vertical guidelines that divide the head circle into four equal quadrants. Center an elongated horizontal oval over the horizontal guideline, and another elongated oval vertically centered between the two bottom quadrants as shown. This will be the muzzle.

2 Add features to the face—the eyes along the horizontal guideline and the nose at the bottom of the smaller, vertical oval (which will be the muzzle). Add a mouth on the muzzle below the nose. Add some fluff to either side of the top of the monkey's head, which will produce a somewhat heart-shaped head. From the right side of the head, draw a curved line starting around the monkey's cheek and arcing about two head lengths down*. Continue the curving line, sweeping it up to create an oval that will be the hindquarters. (*I drew guidelines showing head lengths on the left.)

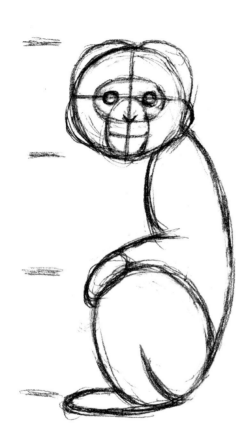

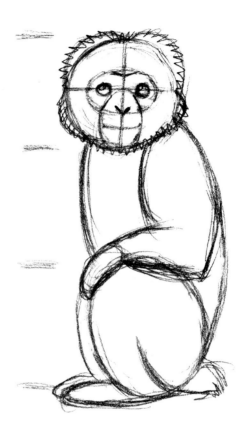

3 Now draw the front of the monkey's arm, curving the line down almost to the hind leg, then curving it in front to rest on what will be its knee as shown. Draw inside the leg to show how it's folded as the monkey sits. Add the foot and the hand. Add some volume to the monkey's cheeks on either side of its face.

4 Add the back part of the monkey's arm, letting it overlap the leg somewhat, bringing it back around and up to line up with the monkey's back. Add the far hind leg and the short tail, and then draw the chest. Add a highlight to the eyes, define the top of the muzzle, and indent the brow line down a little between the eyes. Start adding the fur to the outline of the head.

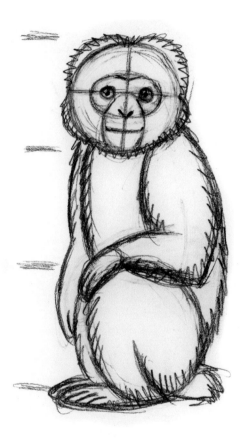 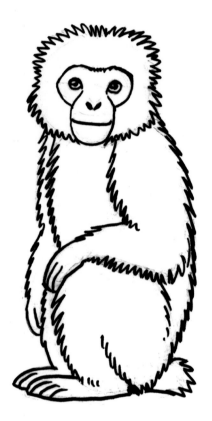

5 Continue adding shaggy fur all around, then add the far arm hanging down. Draw the pupils of the eyes, letting the highlight overlap them a tiny bit. Add the toes on the front and hind feet.

6 Finish the drawing, inking in the final lines and erasing the guidelines.

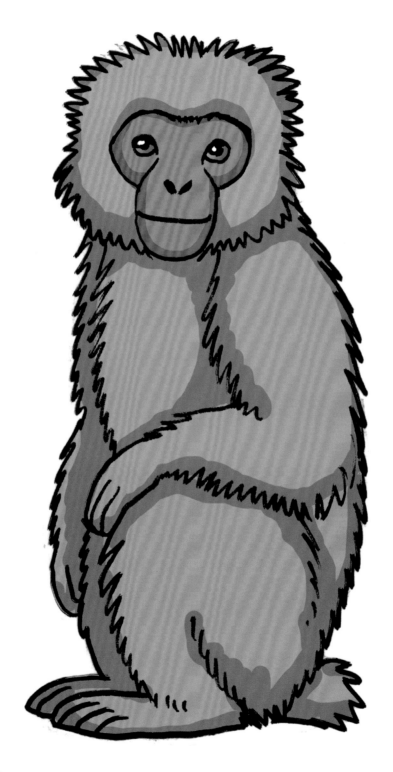

The monkey in color.

DRAWING MYTHOLOGICAL CREATURES

In this final chapter, we'll explore information and drawing tips on various yōkai (Japanese spirits) and other fantastical creatures of Japanese legend, including step-by-step drawing demonstrations.

KITSUNES

Kitsune is the Japanese word for fox, but it can also refer to a powerful yōkai, or spirit, known to be a trickster and shape-shifter who often morphs into a beautiful woman. A kitsune can possess magical foxfire, create illusions, invade dreams, and grow multiple tails with age. A nine-tailed fox is especially powerful and is often white or gold in color. Kitsunes may be good or evil, and always strive to repay their debts. But they may interpret those debts differently, so beware. Its favorite food is fried bean curd, called aburaage. The Pokémon Ninetails and Vulpix were inspired by kitsunes.

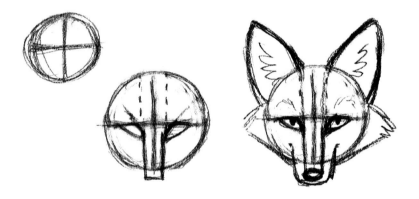

A kitsune or fox head has a long snout, big ears, and slightly slanted eyes. Its pupils are cat-like—vertical, not round.

At its core, a kitsune looks like a fox with multiple tails. It can stand on its hind legs, wear clothes, and even shape-shift.

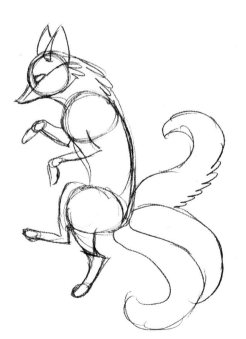

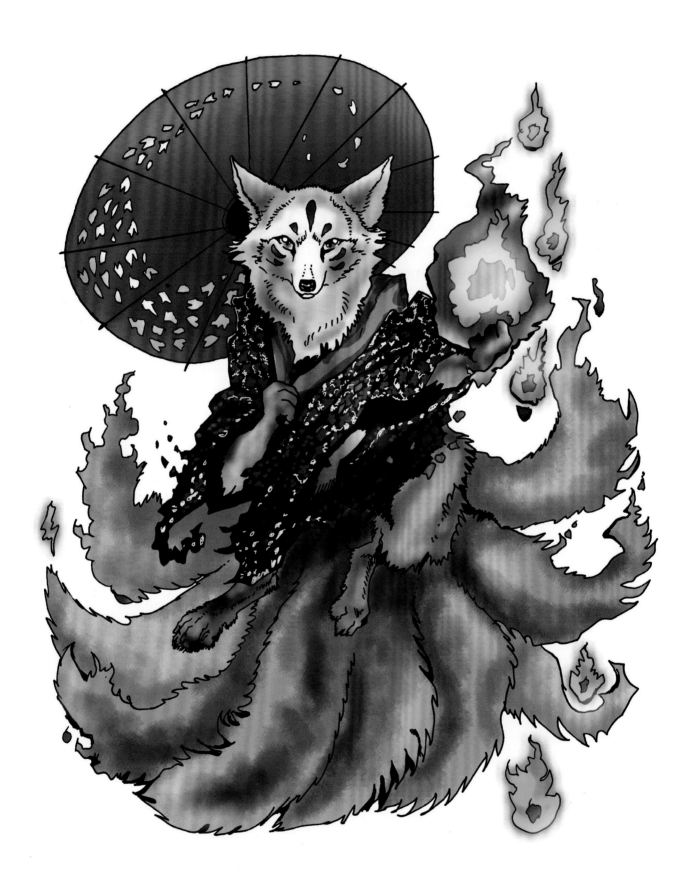

This nine-tailed golden kitsune is an old, wise, and magical creature.

TENGUS

Tengus are yōkai, or spirits, of the mountains that often appear as humanoid birds. The most bird-like resemble crows and are called karasu tengu. The ones that resemble red-skinned humans with a beard and very long nose are called yamabushi tengu. They are often associated with the Shugendo priests who lived in the mountains of Japan and wore their garments, including small black caps, short robes, and sashes with pom-poms. They may hold a khakkhara, a Buddhist ringed staff, or a fan made of feathers. They can fly and may have shape-shifting abilities. Almost always vain, tengus can be good or evil and have even been known to teach humans their exceptional combat skills.

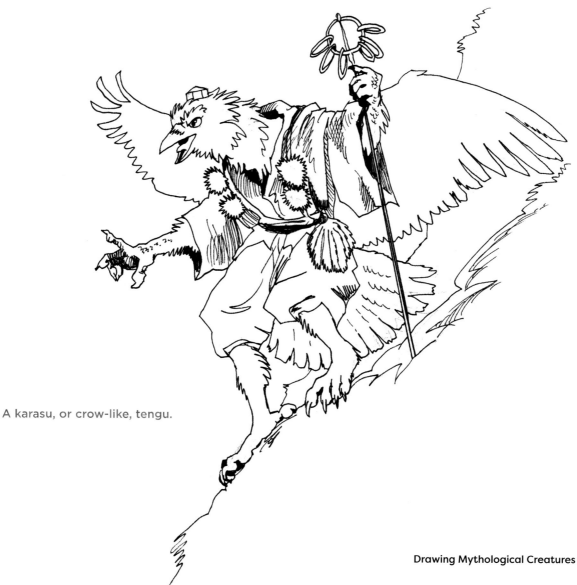

A karasu, or crow-like, tengu.

How to draw a yamabushi tengu mask step by step

1 Draw a vertical oval, which will be the mask/face. Add two crisscrossing vertical and horizontal guidelines, curving them slightly, as shown. This mask is facing toward your left.

2 Add oval eyes along the horizontal guide, slanting up at the outside corners. Make the closer one on your right just a little bit larger. Add angry, bushy eyebrows. Draw a thin oval on top of the head for the priest's cap that tengus are often depicted wearing.

3 Draw large pupils in the tengu's eyes that both point toward center. Add the tengu's very long nose, starting it from the bottom corner of the far eye as shown. Draw a frowning mouth below the nose. Use curving, flowing, and jagged lines to suggest hair behind the mask.

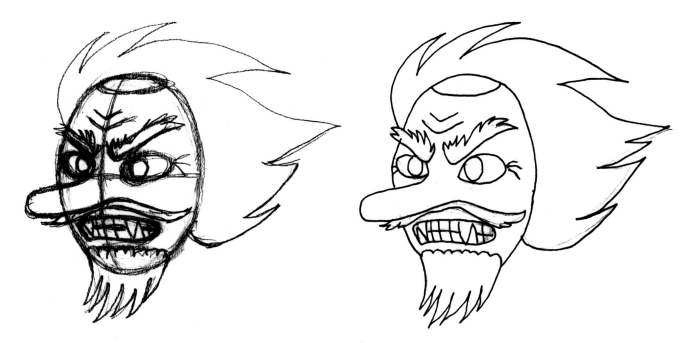

4 Add the lower part of the tengu's mouth if you wish, then add some teeth. Tengus are often depicted with human-like teeth, though in fact they have some long, sharp, fang-like canine teeth. You can add wrinkles to the forehead and corners of the eyes, and sketch in a beard and mustache.

5 Finish your drawing, adding your final lines and erasing guidelines as needed.

The tengu mask in color.

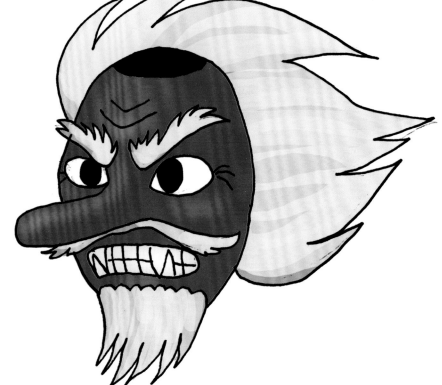

KAPPAS

This water yōkai resembles a turtle and can be highly mischievous, and sometimes outright malignant. Kappas are aquatic and have a depression on the top of their heads that stores water. If they spill this water it may weaken or even kill them. Humans can use this knowledge to their advantage in the case of an encounter with an evil kappa. Always polite, the creature will bow to a human if they bow to it, and humans can escape kappas this way. Kappas may be rather vicious creatures, drowning those who venture close to water's edge, or they may be humorous and helpful, offering advice or repaying a debt. They enjoy cucumbers and wrestling.

A more friendly kappa with a cucumber.

A more menacing kappa lurking in the water.

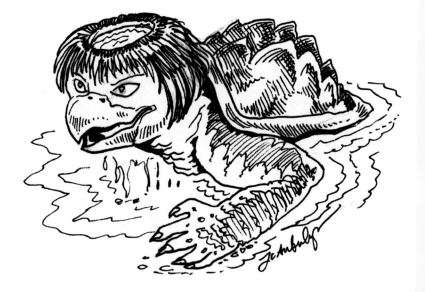

KIRINS

The kirin, or qilin, is an immensely powerful magical creature, said to be benevolent and wise. Kirins are excellent judges of character who only appear in lands governed by a wise and just person, at the birth of a great ruler or sage, and during times of peace. They look something like a scaled dragon/horse with magical, sacred fire flowing out of the legs, head, or neck. Some possess a single horn; some have two. The Japanese kirin is often depicted as more deer-like than the kirins of China and other East Asian countries.

A kirin stands in some grass. It is said a kirin, when it walks, will not harm a single blade of grass.

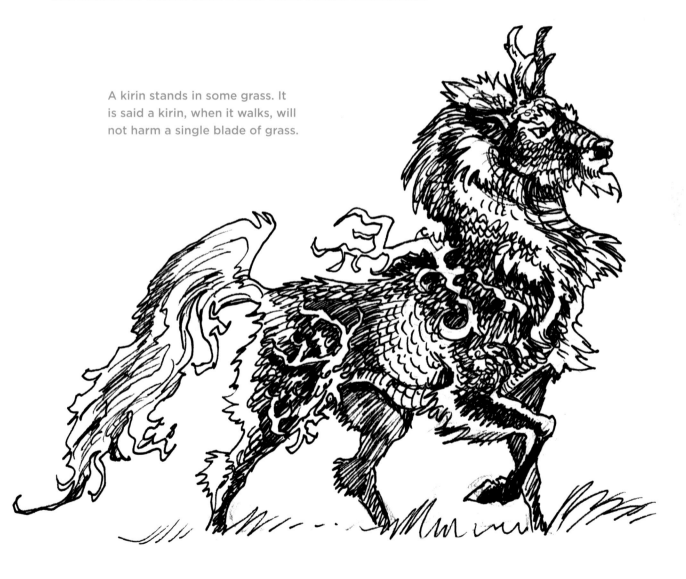

How to draw a kirin head step by step

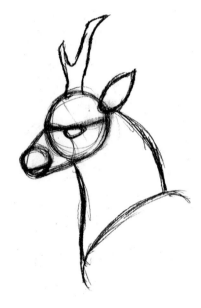

1 Draw a circle for the head, then draw a cone for the snout on the lower left quadrant of the face. Make sure there's a small indent at the point the snout joins the face at the top. The brow will rise up from the muzzle. Keep the snout line smooth and aligned with the lower jawline of the head circle. (See arrows.)

2 Draw a horn (or two) on the kirin's head, and add the eye below the horizontal guideline you drew earlier. Add a mouth to the bottom quarter of the nose circle at the end of the cone. Draw an almond-shaped ear on the back of the head just above the horizontal guideline. Use curved lines to add the neck and chest as shown.

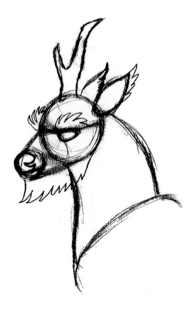

3 Draw bushy eyebrows above the kirin's eyes, and draw a nose with a rounded top and nostrils swirling toward the front like teardrops. Add a second ear, then tufts to the ear, as well as a beard on its jaw.

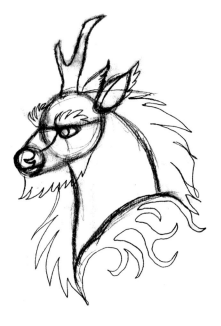

4 Add pupils to the kirin's eyes, and then draw the mane, making long, shaggy strokes to indicate flowing hair in front of and behind the neck. Use the curve of the shoulder to help you place the mystic fire that snakes in forked branches around and from the kirin's body. Draw a line inside the near ear to delineate the inner ear. Add a curved line from the inside corner of the eye down to the nose circle, which will be a guide for your scale placement in step 5.

5 Add scales on the top of the snout, drawing curved parallel lines as shown. Draw a line from the corner of the mouth, curving up with the narrower snout and then arcing around the eye socket where the jaw thickens, ending at the bottom of the ear. Add more scales above this line as you wish. Finish up the rest of the head, cleaning up lines. To separate the mane from the lower part of the neck and shoulder, make long shaggy strokes up from the curved line at the base of the neck that you drew in step 2. Fill in with scales to your taste.

6 Finish the drawing, inking final lines and erasing guidelines as needed.

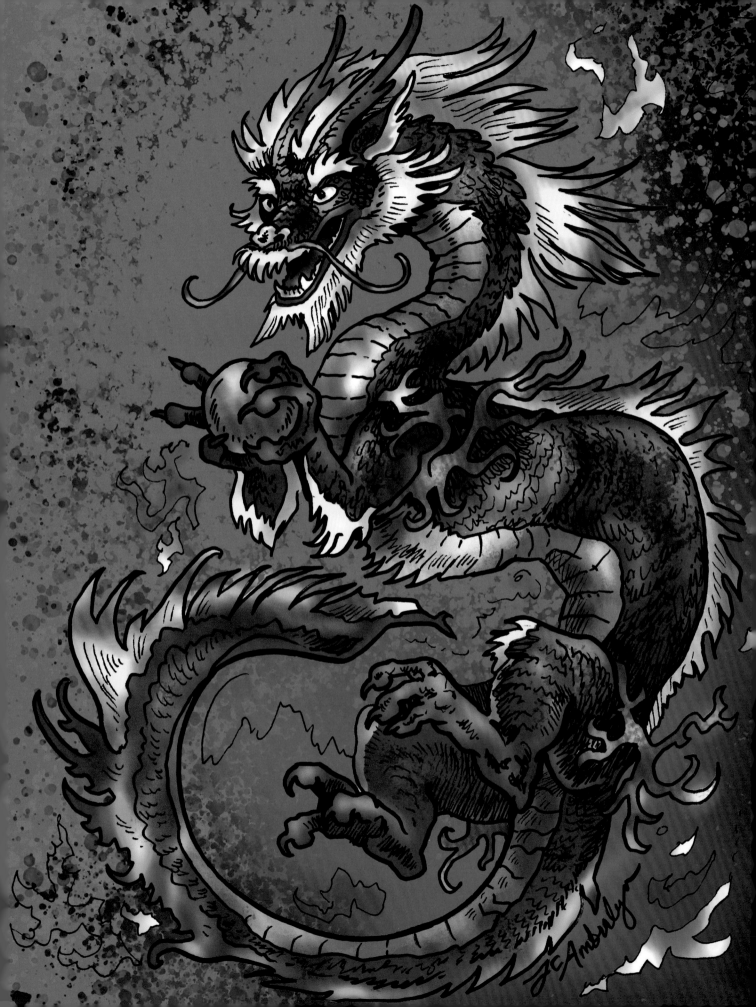

DRAGONS

Asian dragons, unlike their traditional western counterparts, are often depicted as wise and divine beings. These reptilian creatures may guard important people or places and are associated with luck and prosperity. They often feature horns, bushy eyebrows, cheek whiskers, and even manes. Asian dragons usually do not have wings. Japanese dragons are often depicted with three toes and associated with water.

Opposite: A Japanese three-toed dragon.

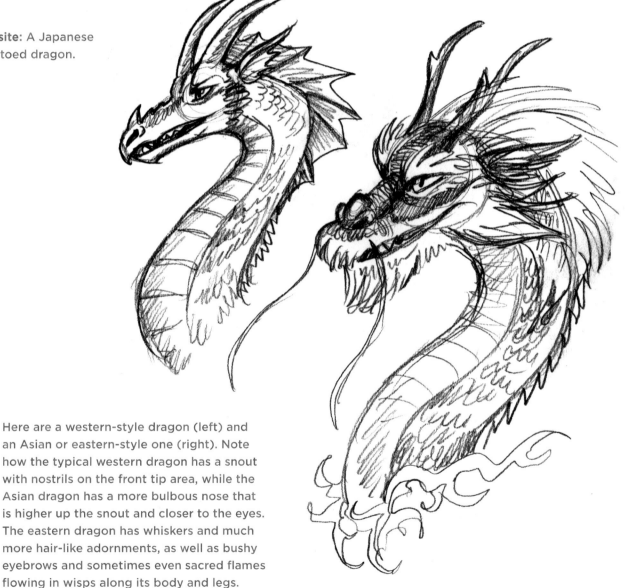

Here are a western-style dragon (left) and an Asian or eastern-style one (right). Note how the typical western dragon has a snout with nostrils on the front tip area, while the Asian dragon has a more bulbous nose that is higher up the snout and closer to the eyes. The eastern dragon has whiskers and much more hair-like adornments, as well as bushy eyebrows and sometimes even sacred flames flowing in wisps along its body and legs.

How to draw a dragon step by step

1 Draw a circle for the head, then another, slightly larger circle below it for the chest, and a circle below that for the hips. Keep moving the circles a bit to the right each time you draw one so that the head circle juts out toward your left side. Connect the circles with a wavy line on the right side for the dragon's back and neck.

2 Add an eye and then a muzzle (a cone shape with a small circle at the end for the nose) to the head circle. Draw a wavy line to connect the head, chest, and hips at the belly on the left side, and then draw a curving tail underneath the hips.

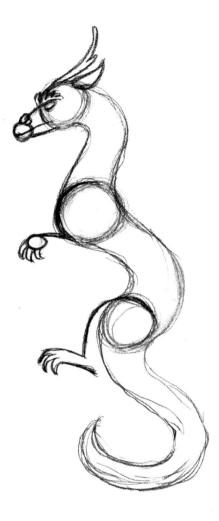

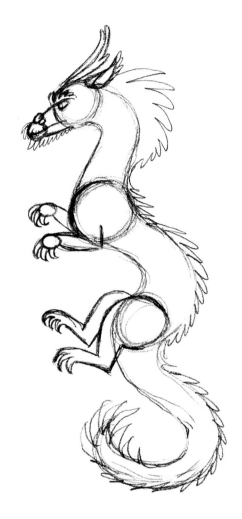

3 Draw a bushy eyebrow over the dragon's eye. Add an oval for the dragon's nose on top of its muzzle just behind the nose tip circle, and then add a smaller oval below that for a nostril. Define the mouth, then a horn and ear on the dragon's head. Begin the dragon's front top leg, extending a line from the bottom of the chest circle to a smaller circle and three clawed toes. Do the same with the hind leg from the hip, curving up and toward the front of the hip circle.

4 Add a pupil to the eye, and draw some shaggy whiskers protruding from the tip of the snout and the chin. Add a tuft of hair to the ear and another horn on the head. Finish the legs, adding the underside to the two legs drawn in step 3, and then echo those with the legs behind them, as shown. Draw the mane along the back of the head, continuing it all the way down the back. Add scales to the tip of the tail.

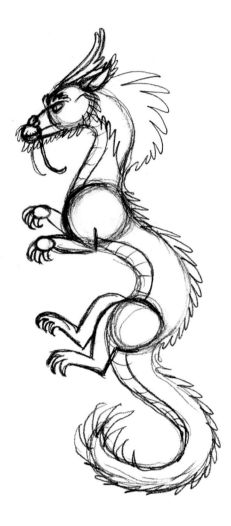

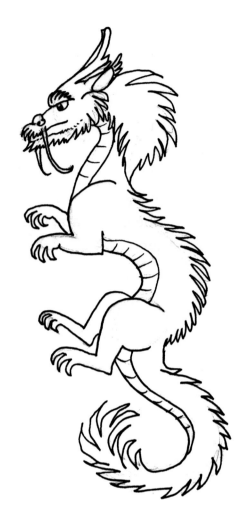

5 Finish the dragon, adding the other ear and drawing long whiskers curving down from near the nose. Add belly scales by drawing curved, parallel horizontal lines all along the dragon's front, as shown. Draw the remainder of the mane on the dragon's neck, bringing a shaggy, squiggly line back up to meet the head. Last, draw some cheek whiskers.

6 Finish the drawing, inking in the final form and erasing pencil lines as necessary. Add a highlight in the eye if you wish.

BAKENEKOS/NEKOMATAS

Bakenekos and nekomatas are both yōkai demon cats, usually associated with a housecat that has lived a long time, reached a certain weight, or been allowed to grow a long tail. Usually, but not always, evil-natured, this creature becomes a bakeneko at first, which can shape-shift into a human form and cause havoc in human households. Over time, they may become an even more powerful form of demon cat, the nekomata, which grows two tails. Nekomatas can reanimate a corpse by jumping over it!

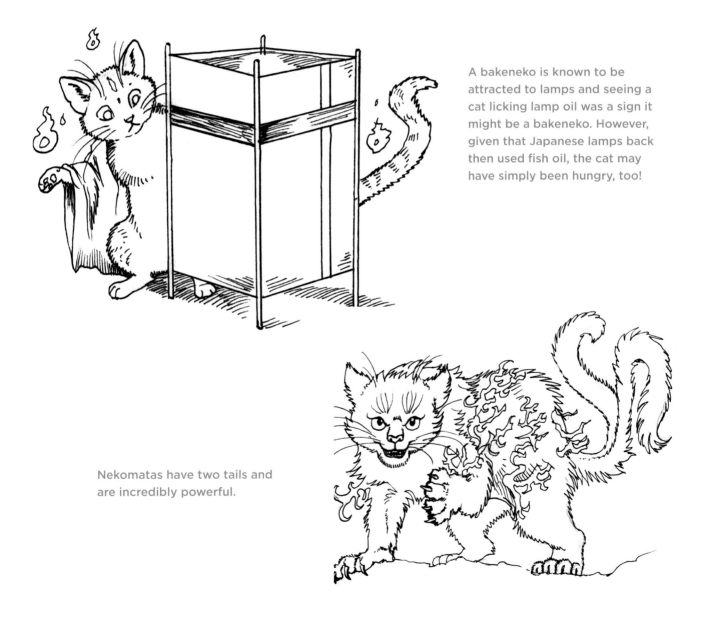

A bakeneko is known to be attracted to lamps and seeing a cat licking lamp oil was a sign it might be a bakeneko. However, given that Japanese lamps back then used fish oil, the cat may have simply been hungry, too!

Nekomatas have two tails and are incredibly powerful.

BAKUS

Bakus are capable of eating bad dreams, and are often called upon to either eat children's nightmares or to provide protection from them. They are a chimerical mix of creatures, including a tapir and/or an elephant, tiger, and ox. While they can devour nightmares, respect must always be given them, for over-reliance on a baku may cause it to eat one's hopes and good dreams, as well. The baku is often depicted in yellow and black. The Pokémon Drowzee was inspired by a baku.

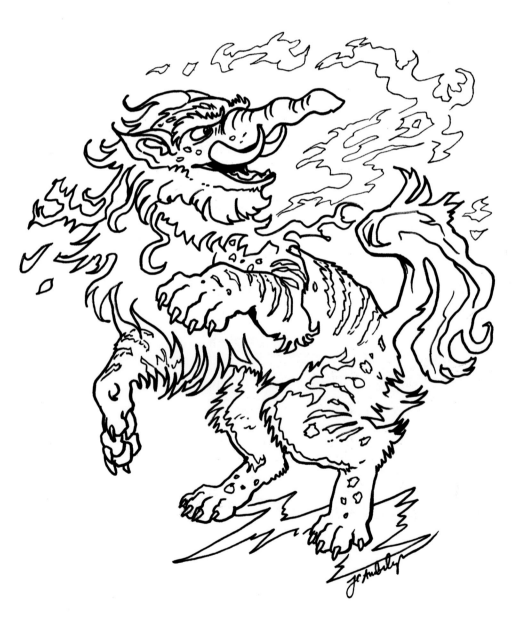

Bakus always have a tapir or elephant-like long snout with tusks. Other features may vary, such as hooves or paws. The baku is often striped or spotted, with sacred fire flowing from its body.

KOMAINU/FU DOG

Fu dogs are powerful lion or dog-like creatures that are fierce guardians and protectors. Believed to have originated in China as a more lion-like beast, the fu dog in Japan gained some more canine characteristics as well. Whatever the form, it is generally depicted as stocky, muscular, with a broad muzzle, a mane, and a flowing tail. Fu dogs are often depicted in a male and female pair, with the female gently placing her paw on a cub and the male placing his paw on a globe or ball. Often one will have its mouth open and the other closed, representing an "ahh" and "mmm" sound, or "ohm," which is said to represent the universe in Hinduism.

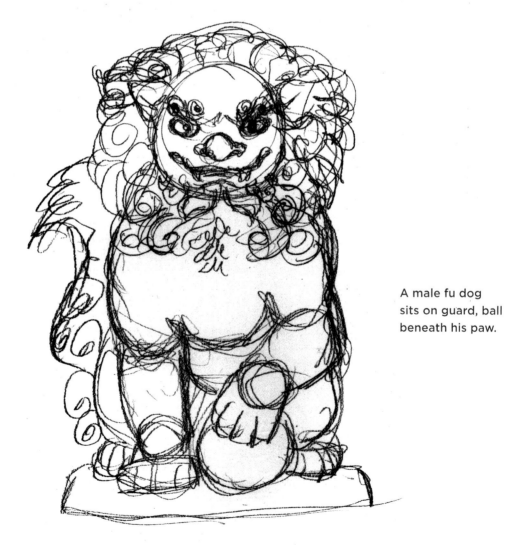

A male fu dog sits on guard, ball beneath his paw.

CONCLUSION: PUTTING THIS ALL TOGETHER

Here we come to the end of this book, but hopefully the beginning of a new chapter in creativity—your creativity. My wish is for this book to provide some inspiration and ideas for you to begin, or continue, your own creative journey. Some say there "are no new ideas under the sun," but truly, there are new ways of putting ideas together in a way that only you will know how to do. Some things may seem obvious and common to you, but others see them for the first time through your eyes and hand. Use this book and many like it, your own experiences, and everything you see, experience, and learn; throw them all into the mix, and see what comes out.

EXERCISES TO HELP YOU PRACTICE AND SEE FROM A NEW ANGLE

Finally, I'd like to add a few exercises I've found helpful in my own drawing classes. These are suggestions and everyone has a different way of being productive. These are tips my students have found useful in the past.

Warm ups: Nothing feels more daunting than a blank page! Sometimes it can help to simply put your pencil on paper, or pen to computer tablet, and start moving. See what comes out. Perhaps find some live models or photographs and sketch from those, not spending too much time on any one drawing, to loosen up your hand and get the creative juices flowing, as it were.

Gesture sketches: Sometimes I find an Internet site with human models that change pictures every 30 seconds or two minutes and I do quick sketches of those, which can help get me in a drawing mood.

Subject studies: I also get inspired looking at others' work. Browsing art websites or looking through an art book can be a creative boost. Copying others' work (with credit to the original artist if you share that art) can help you learn how they have resolved some creative challenges.

Challenge yourself to draw things you haven't drawn before. It will expand your skills. **Draw upside down**: Draw things *in* a way you haven't drawn before, or with a new artistic medium. Betty Edwards' book, *Drawing on the Right Side of the Brain*, features an excellent exercise of drawing subjects upside down. Flip a photo and draw it that way. It will force you to really look at proportions and spaces, rather than what you think is supposed to be there. Use colors or try art styles you haven't tried before.

Have a favorite artist? See if you can draw something in their style. Learn about composition and line thickness. Never stop learning! Obviously, if you're reading this book, you already know the value of gaining knowledge and insight. Please never lose that enthusiasm and dedication, the world needs it.

Finally, remember to have fun and not be afraid to try new things, too. Your joy will be shared with all who see your work.

INDEX